my sweet home

Childhood stories from a corner of the city

SAMINA MISHRA

SHERNA DASTUR

AND CHILDREN OF OKHLA

WITH PHOTOGRAPHS BY KUNAL BATRA

MAPIN PUBLISHING

First published in India in 2017 by
Mapin Publishing
706, Kaivanna, Panchvati, Ellisbridge,
Ahmedabad -380006, INDIA

Simultaneously published in the
United States of America in 2017 by
Grantha Corporation
77 Daniele Drive, Hidden Meadows,
Ocean Township, NJ 07712 • E: mapin@mapinpub.com

DISTRIBUTORS
North America
Antique Collector's Club
T: +1800 252 5231 • F: +413 529 0862
E: sales@antiquecc.com • www.accdistribution.com/us

United Kingdom and Europe
Gazelle Book Services Ltd.
T: +44 1 5246 8765 • F: +44 1524 63232
E: sales@gazellebooks.co.uk • www.gazellebookservices.co.uk

Thailand, Laos, Cambodia and Myanmar
Paragon Asia Co. Ltd.
T: +66 2877 7755 • F: +66 2468 9636
E: info@paragonasia.com

Malaysia
Areca Books
T: +604 2610307
E: arecabooks@gmail.com

Rest of the World
Mapin Publishing Pvt Ltd.
T: +91 79 40 228 228 • F: +91 79 40 228 201
E:mapin@mapinpub.com
www.mapinpub.com

Text, Images © Samina Mishra, Sherna Dastur

ISBN: 978-93-85360-19-0 (Mapin)
ISBN: 978-1-935677-76-5 (Grantha)
LCCN: 2016951189

Copyediting: Ankona Das/Mapin Design Editorial
Editorial Management: Mithila Rangarajan/Mapin Editorial
Production: Gopal Limbad/Mapin Design Studio
Design: Sherna Dastur
Printed at Parksons Graphics, Mumbai

FOREWORD

Jamia Millia Islamia's foundations are rooted in the struggle for India's independence and the idea of India is inextricably linked to the institution. The founding fathers of the institution envisioned Jamia Millia Islamia in the forefront of the movement that represented the nationalist aspirations for education and cultural renaissance.

Jamia has consistently endeavoured to respond to the changing social contexts both within the university and outside it. Given the unique and organic way in which the university has grown along with the larger community, as you will see in this book, Jamia sees itself engaging with the community and not just with the enrolled students. One of the ways in which the university seeks to do this is through the Outreach Programme. Conceived in 2005 with the mandate of reaching out to the community both within the university and outside it, Jamia Millia Islamia's Outreach Programme organizes a variety of activities and events with a strong emphasis on including the wider community in a discussion on social and cultural issues. This commitment that the Outreach Programme first supported, the workshop with children from the Jamia schools, led to this valuable book — *My Sweet Home: Childhood Stories from a Corner of the City*.

My Sweet Home contains children's ideas, their ways of seeing, as well as an adult perspective that underlines why we must pay attention to children's experiences. Jamia Millia Islamia recognizes the importance of giving our children opportunities for self-expression and dialogue and this book is a testament to this. The workshop conducted by Samina Mishra and Sherna Dastur provided our children with this opportunity and now the book can go on to inspire many readers.

It is also fitting that children are prioritized in Jamia Millia Islamia, an institution that began as a school seeking to educate children holistically. Children are not separate from our society but we often push them to the margins. *My Sweet Home* provides a gentle window into the minds of children growing up in this corner of our diverse city. It has been a pleasure to support the project and I hope the book reaches children and adults alike, the former to listen to their peers and the latter to remember that children must be heard.

Prof. Talat Ahmad
Vice Chancellor, Jamia Millia Islamia

Stories lie in the corners of every city — stories that everyone knows, stories that are hidden, sometimes forever, and stories that anyone could find if only they were looked for. Sometimes these stories – the last kind – never get told because no one bothers to look for them or even at them. This book is about those stories, from a corner of my city.

Okhla is a neighbourhood on the banks of the river Yamuna, comprising several small, crowded neighbourhoods like Batla House, Shaheen Bagh, Noor Nagar, Abul Fazal Enclave and Jamia Nagar. It was once a small village on the south-eastern edge of Delhi but the city grew to claim it. In the late 1940s, the Jamia Millia Islamia, a school that later grew into a university, was moved to Okhla. Jamia, as the university is popularly called, was set up by a group of educationists as part of the nationalist struggle for freedom from British rule. In 1920, Mahatma Gandhi had called for a boycott of British schools and colleges and asked Indians to create their own institutions. Jamia was one of these, founded by a group of enthusiastic young men – supported, less visibly, by a lot of women. Most of these people were Muslim and so were many of the older residents of the village. As the area developed, it began to attract more people, often family members and friends of those already living in Okhla. They came from small towns and villages to study, find jobs and make a better life.

A sad fact of India's history is that people are often discriminated against for different reasons – for example, religion or caste. Okhla has attracted Muslim families over the decades who face difficulty in finding houses in other parts of the city due to religious discrimination or because they fear communal riots and feel that they will be safer in an area where the residents are mostly Muslims. So despite problems – bad roads, erratic electricity, contaminated water — people throng to this "Muslim area", leading some to refer unkindly to it as "Mini Pakistan".

In September 2008, an incident took place in Batla House. The Delhi Police stormed into a house to arrest some young men who they claimed were terrorists. In the process, two of the men were killed and a police officer who was injured, died later. Suddenly, Okhla was on every news channel and everyone seemed to talk about it as an area that supported terrorists. There is still a debate on what exactly happened and whether the men were indeed terrorists, but the encounter did change many things for the residents of Okhla and how they are looked at. It is not uncommon to hear responses like – "Okhla? Oh, that's a bad neighbourhood. Terrorists!"

I have lived in Okhla and still work from there. My parents and uncles and aunts live there. Okhla has been home to me and to many like me for a long time. The picture of Okhla presented on the news channels on television seemed to have something missing. And so, I began to think about what was being overlooked that could connect Okhla's story to the story of other neighbourhoods, which would allow people to interact with each other in ways that news stories did not let them. The answer that I felt was — everyday life. Everyday life in which people went to work and children went to school, in which birthdays were celebrated and kites flown, in which exams were taken, friendships made and broken, cricket matches played etc. Sounds pretty similar to your everyday life, doesn't it?

This book is an attempt to tell many such "everyday-life" stories of Okhla. Come, walk through these streets and share these stories because stories, as I once read in a book, have to be told otherwise they die.

–Samina Mishra

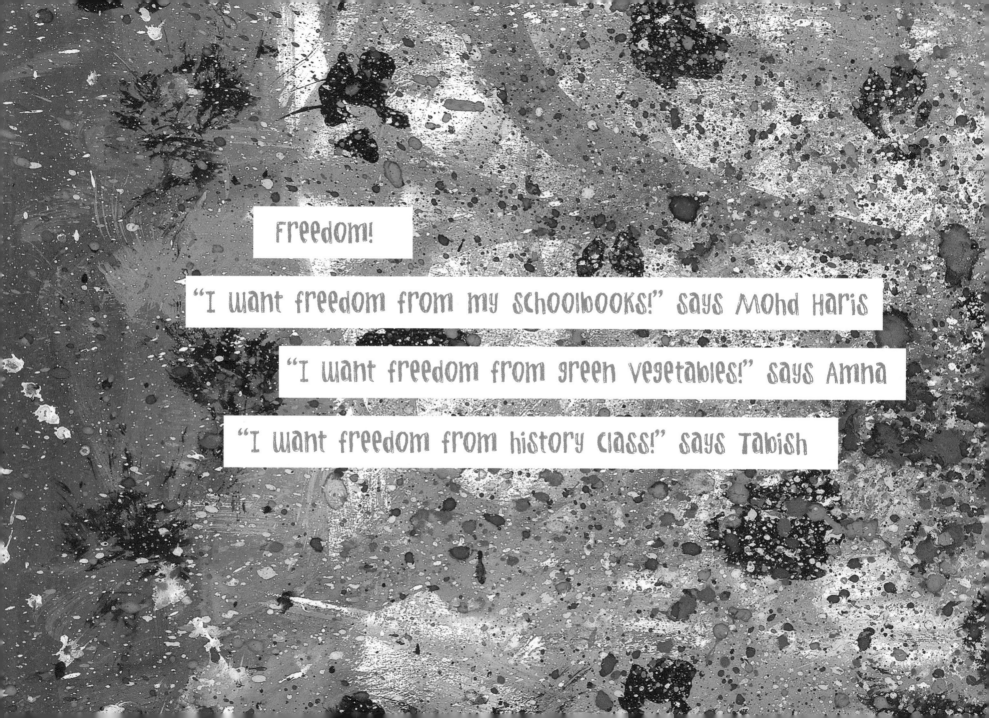

Freedom!

"I want freedom from my schoolbooks!" says Mohd Haris

"I want freedom from green vegetables!" says Amna

"I want freedom from history class!" says Tabish

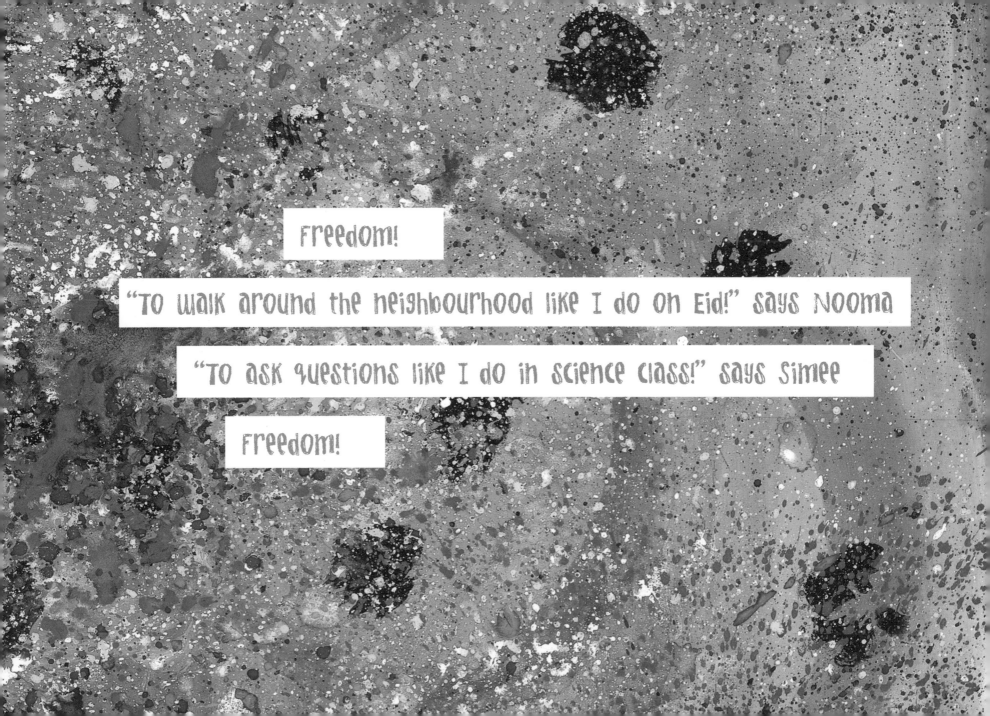

Freedom!

"To walk around the neighbourhood like I do on Eid!" says Nooma

"To ask questions like I do in science class!" says Simee

Freedom!

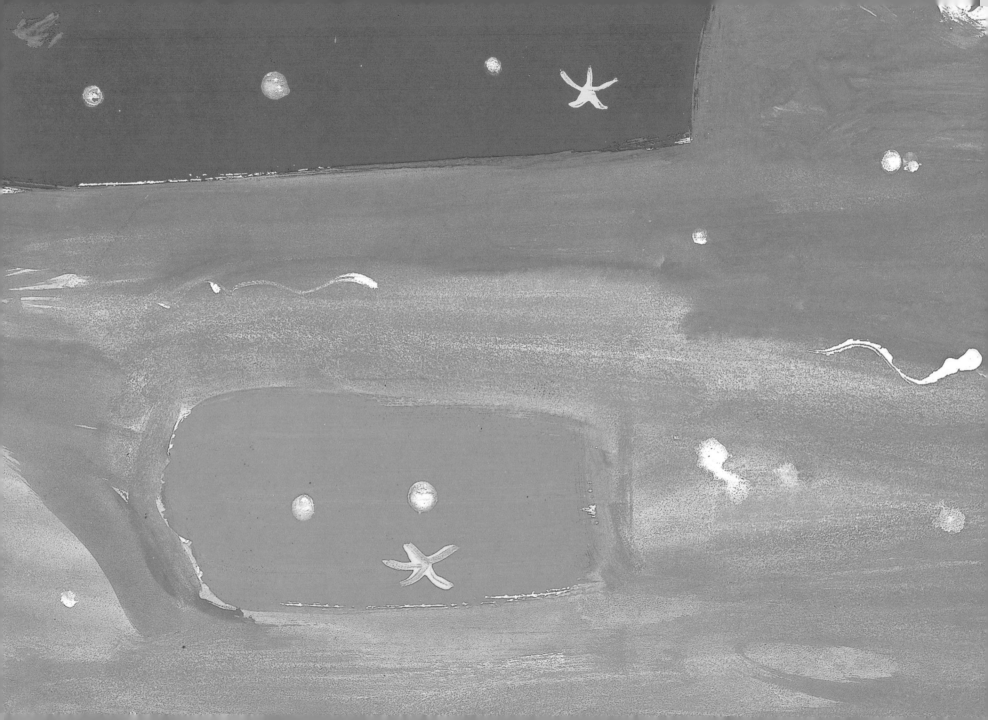

"To fly like a bird in the sky!" says Shahana

"A kite in the wind!" says Anam

Freedom!

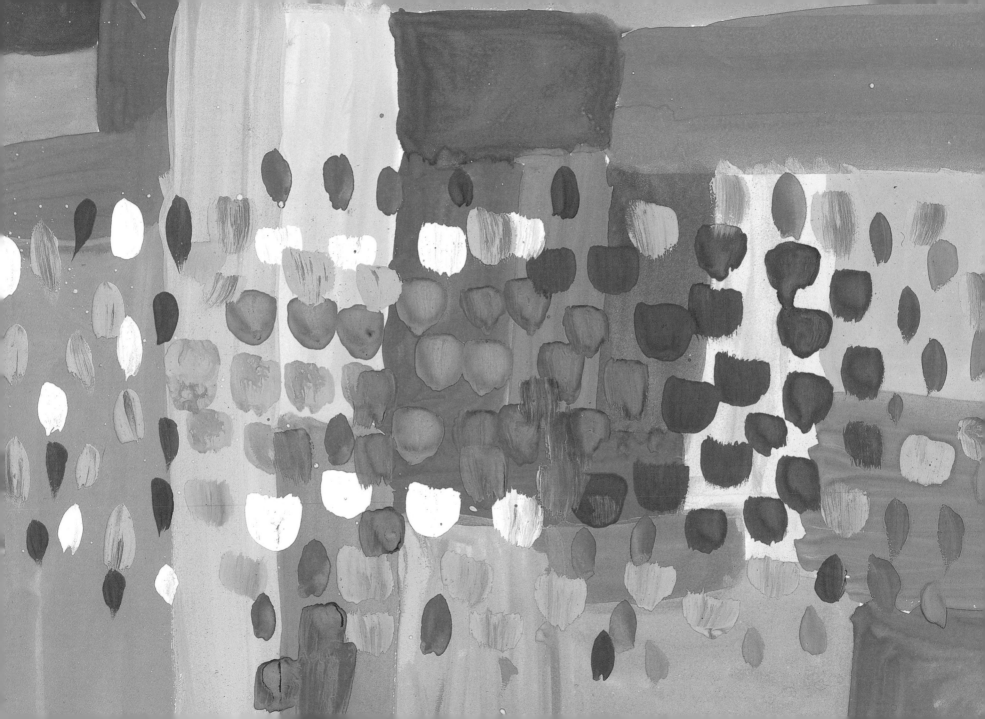

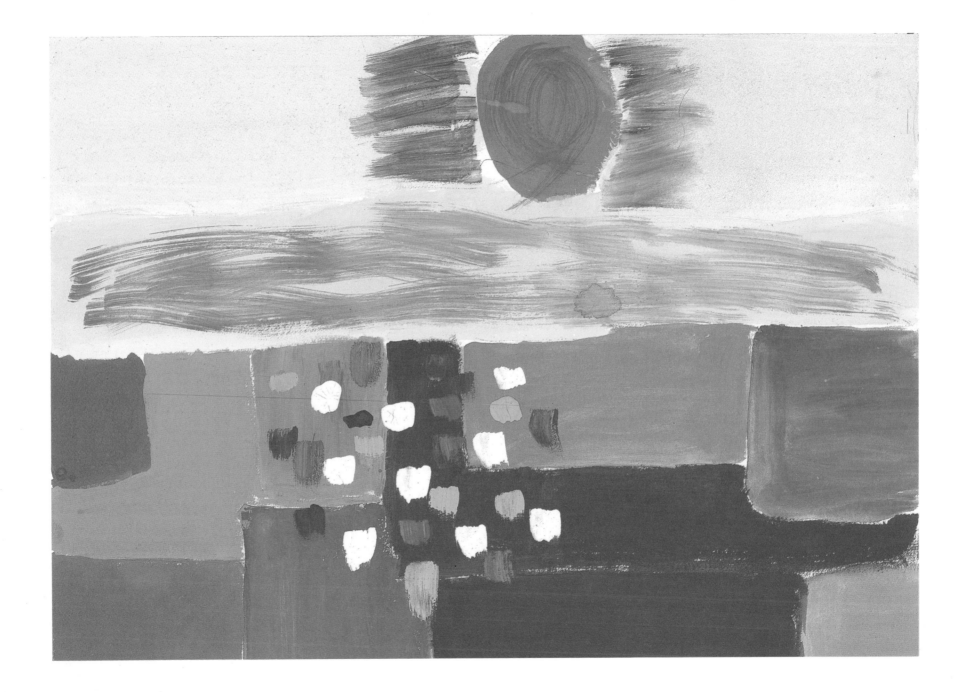

This morning, I woke up and went upstairs to the terrace. I looked at the plants carefully. There was mist all around and on the plants I could see tiny droplets of water. I was brushing my teeth on the terrace. Suddenly, the sun appeared from between the clouds. When the sunlight fell on the beautiful green leaves, their image was reflected in my eyes. The water droplets on the leaves were looking so beautiful with the sunlight falling on them. The mist was lifting from around us. I felt happy looking at this sight.

Abu Bakr

My name is Nida. I am very talkative. When I get into class, I talk a lot to all my friends. Even so, my mother still calls me very smart. Once, when I got to school, I saw that there was a writing competition. Since then I enjoy writing. Once, my brother called me dark; it made me very angry and we had a fight. I like singing and playing basketball. I sing songs with my friend every evening.

Nida

I like wearing mufflers. They make you look stylish, like film actresses. One day, I went to the market and looked at many mufflers but Mummy didn't let me buy any. That's because she had already bought one for me as a surprise and it was much better than the ones we'd seen. I hugged her and wore my muffler, happily.

Anam Fatima

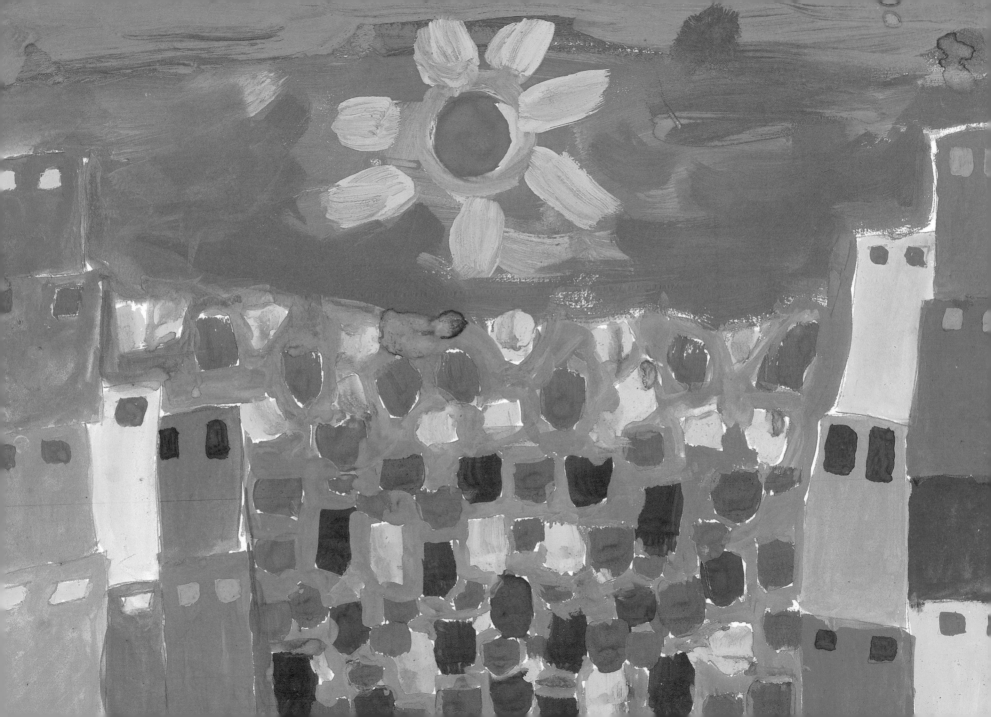

Today, I'm going to tell you about my neighbourhood. The people in our neighbourhood are very nice. If someone is in trouble, they always help. Once, there was a man who really needed some money. He needed the money to pay his electricity bill and if he was not able to, he would be jailed. Oh, I forgot to tell you that I live in Batla House. And that man was also from Batla House. Poor man, he was not well-off and owed five thousand rupees. But all he had in the house was five thousand rupees. So, he would put it off. He'd say that he will pay it later. But the electricity department was very strict with him. So, what was he to do? Now, listen to this! When people in our neighbourhood heard this, they felt very bad. One of the men wrote a cheque for five thousand and gave it to him, saying that he should ask in case he needed more. We were not at home at that time, otherwise we would have helped too. We are lucky that we live in Batla House. When someone asks me where I live, I tell them with great pride that I live in Batla House.

Aliya Khan

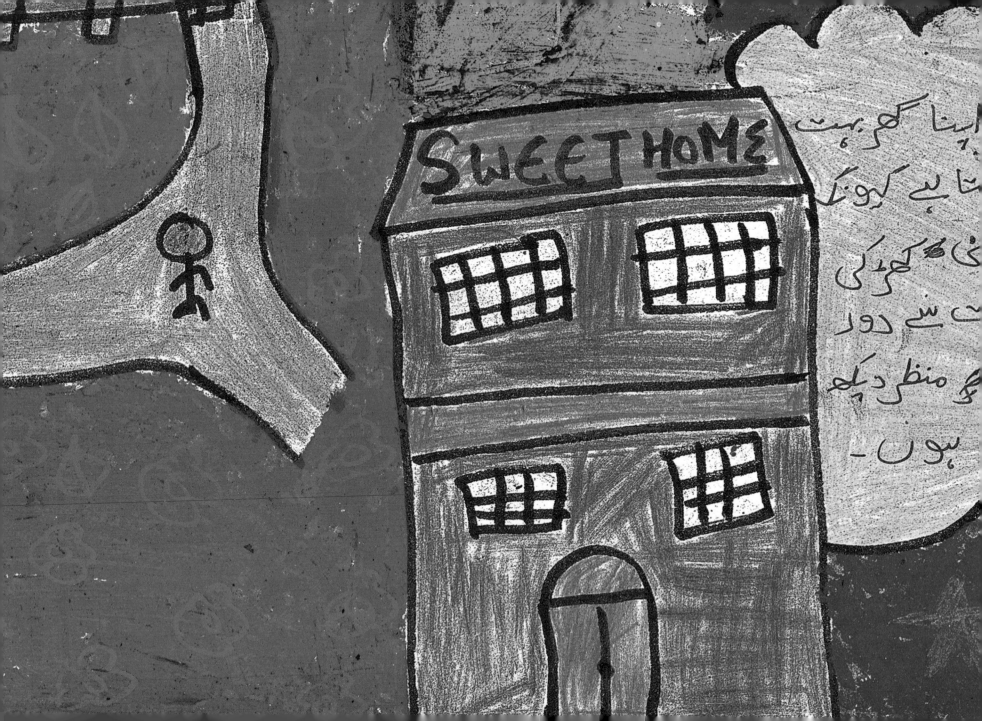

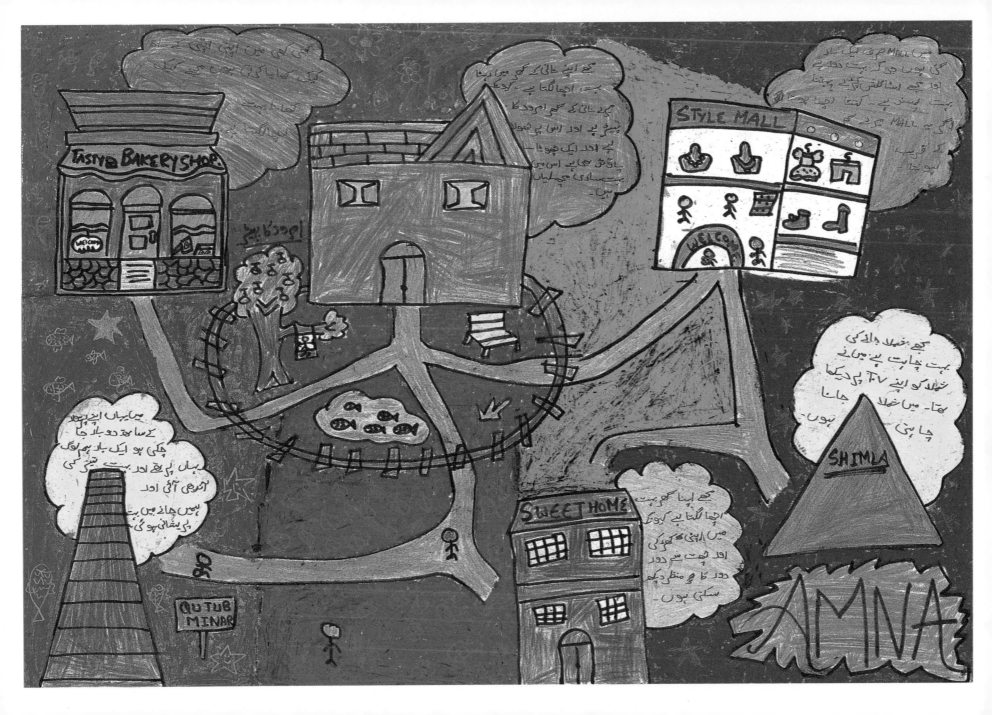

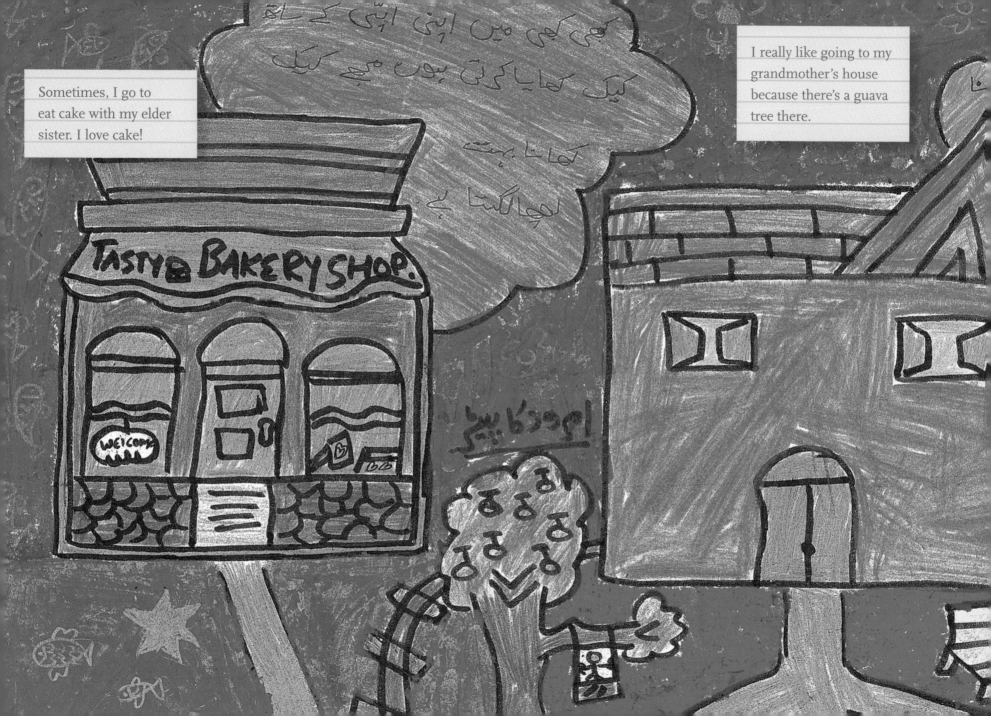

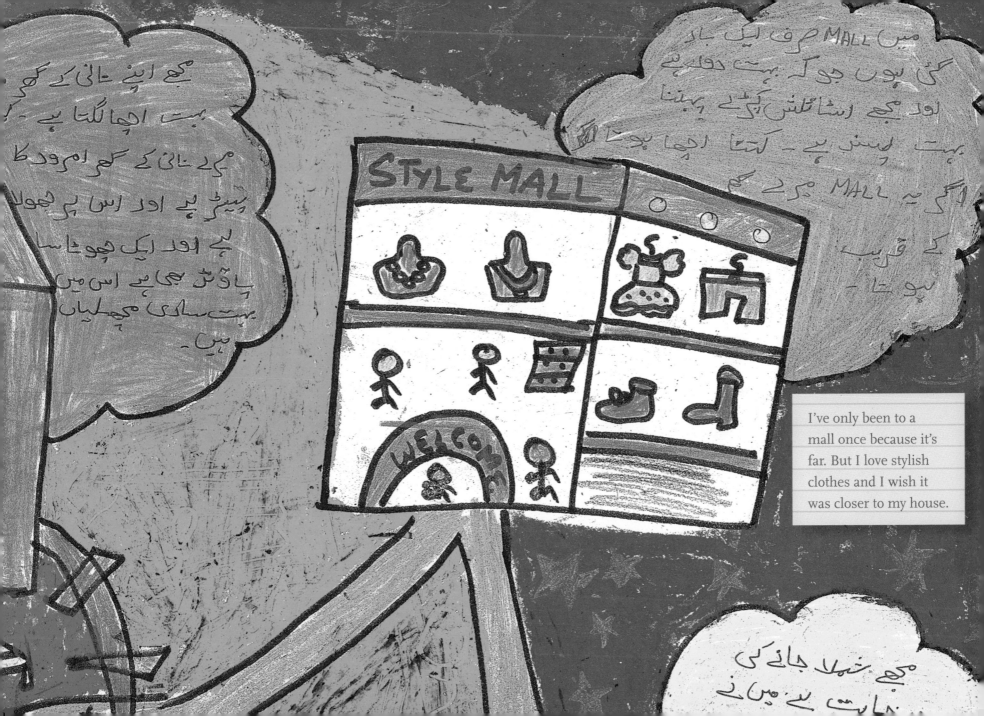

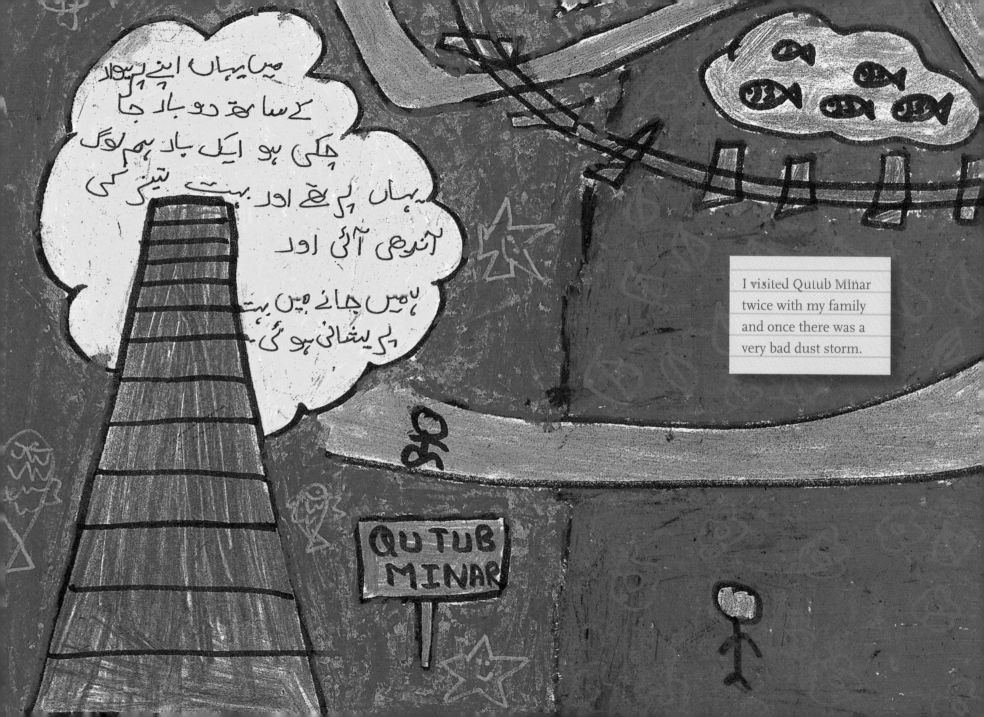

I saw pictures of Shimla on TV and I really, really want to go there.

مجھے شملا جانے کی بہت چاہت ہے میں نے شملا کو اپنے ٹی وی پر دیکھا تھا۔ میں شملا جانا چاہتی ہوں۔

SHIMLA

مجھے اپنا گھر اچھا لگتا ہے کیو میں اپنے

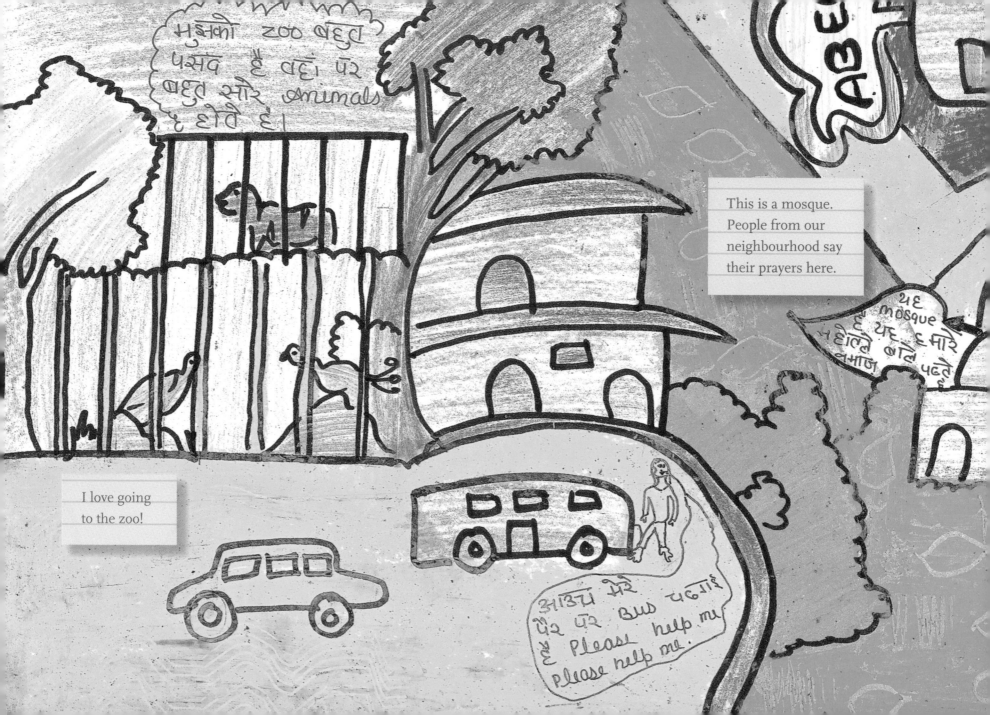

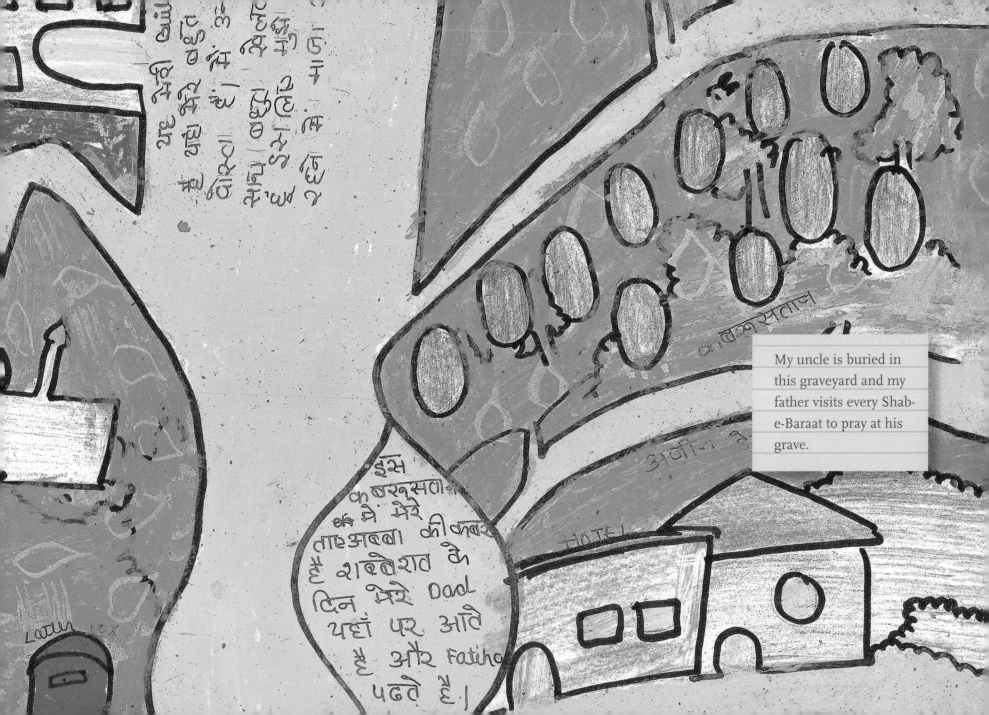

My uncle is buried in this graveyard and my father visits every Shab-e-Baraat to pray at his grave.

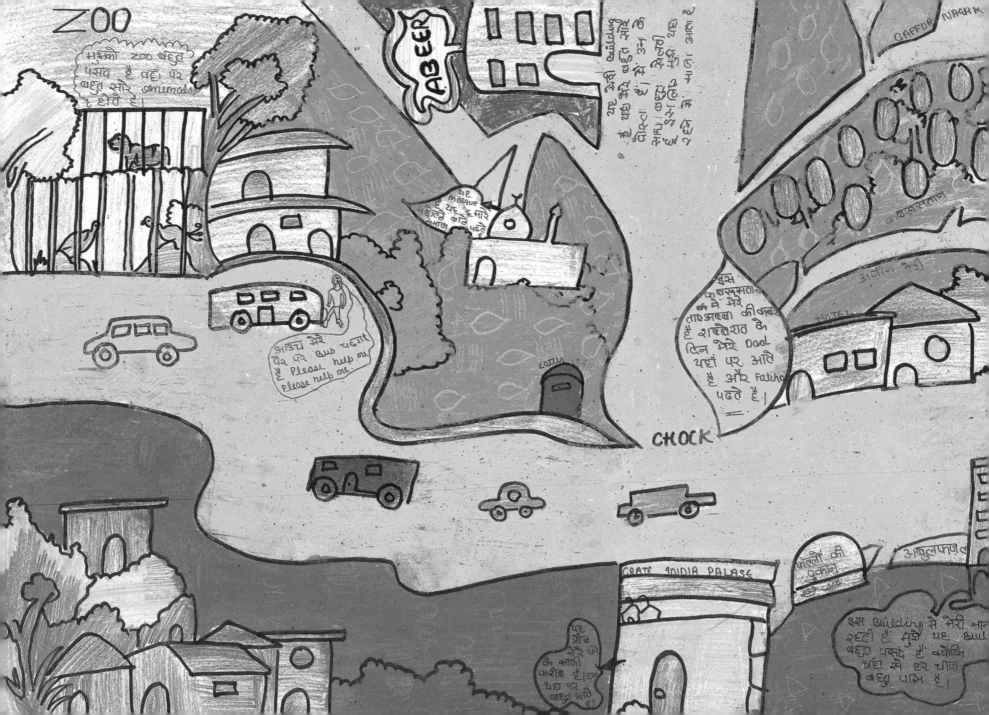

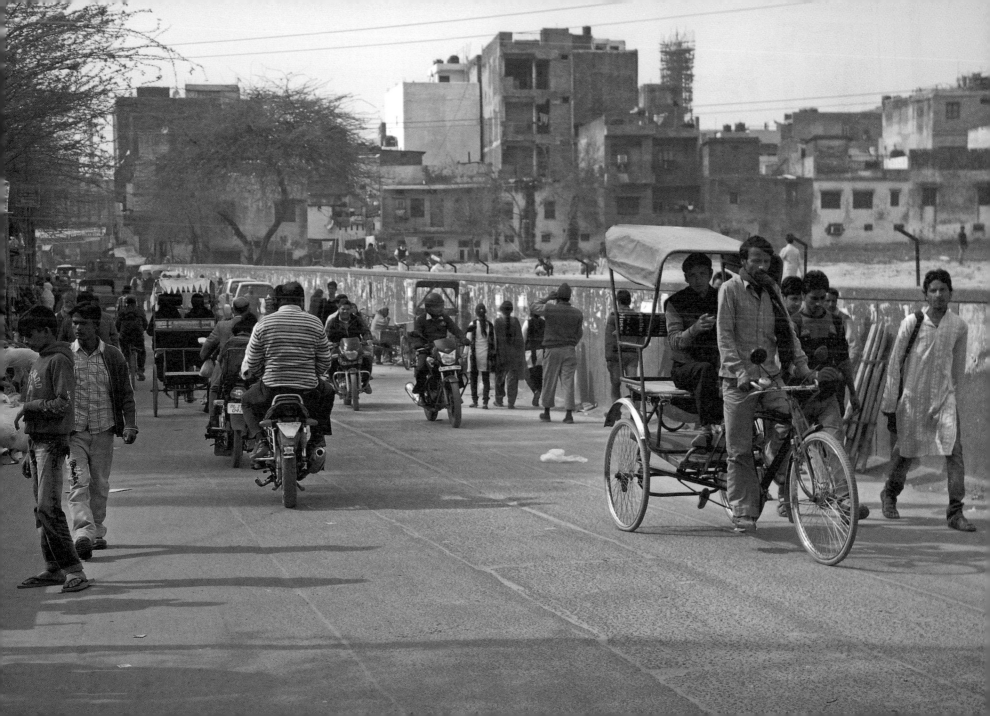

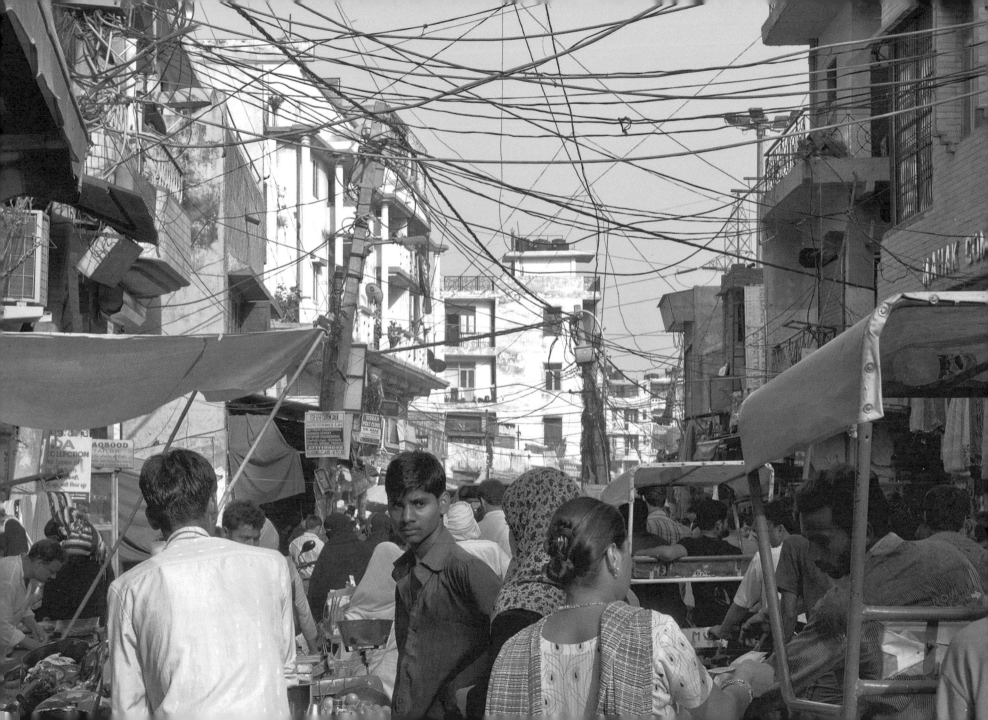

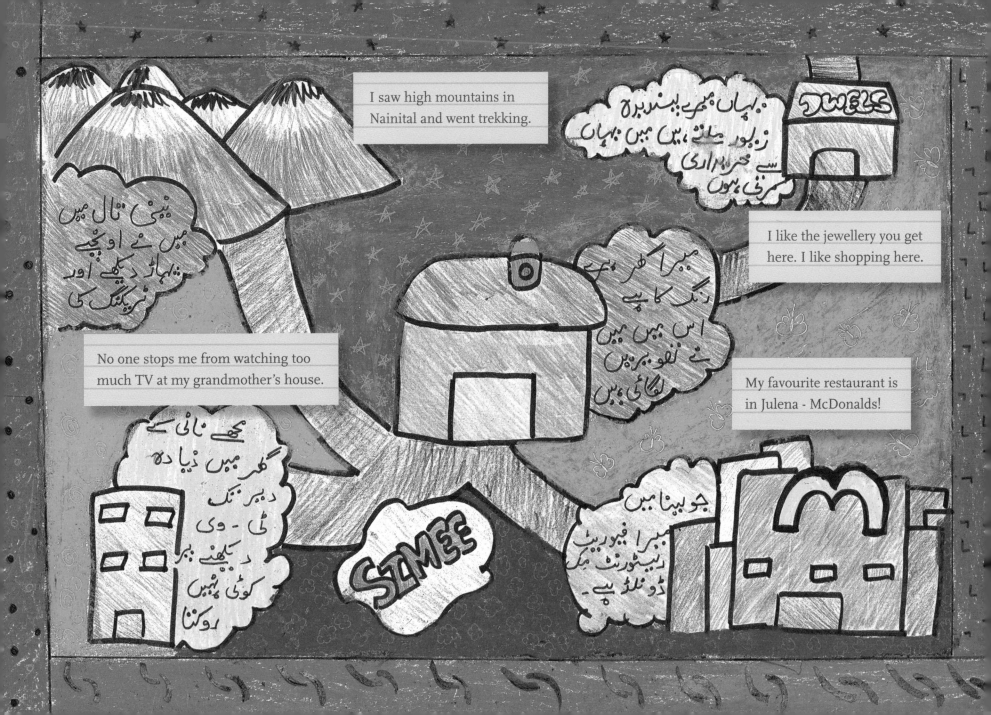

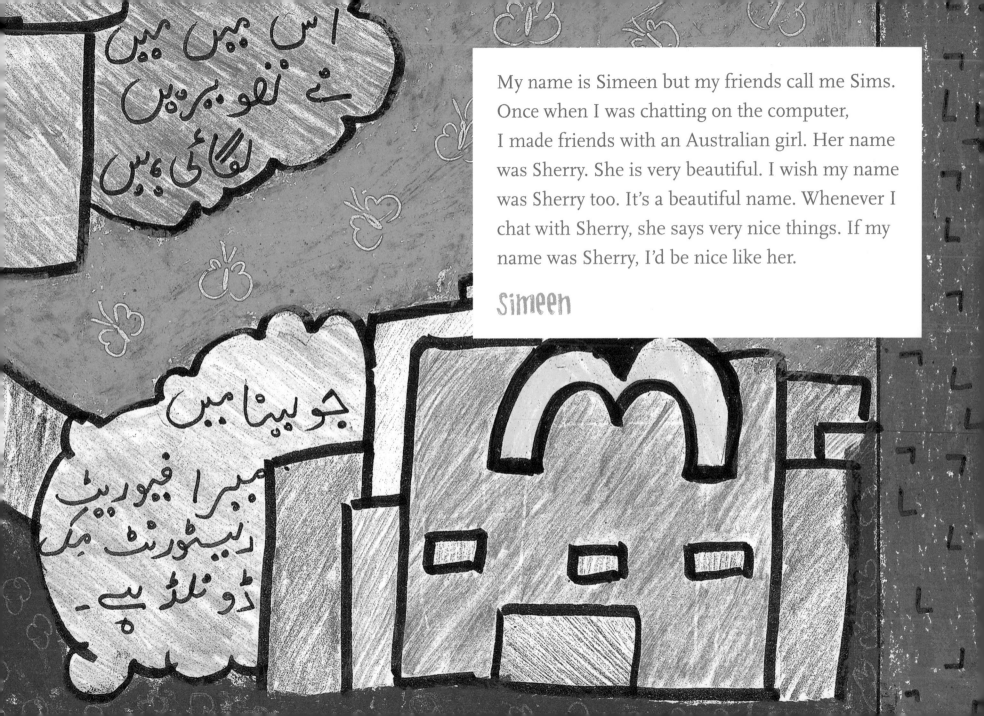

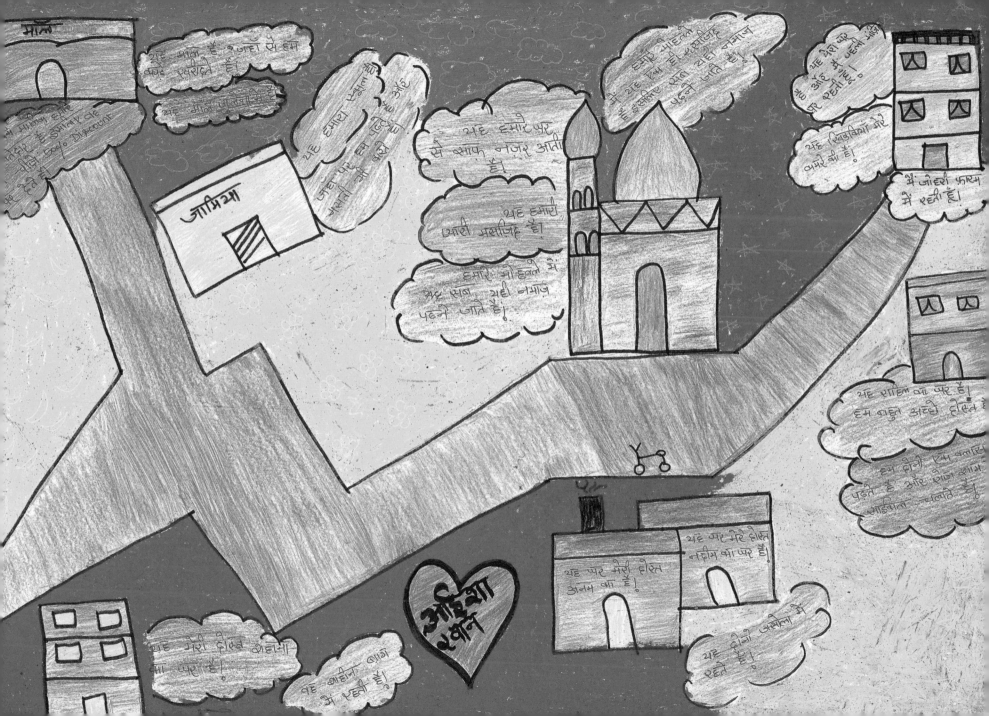

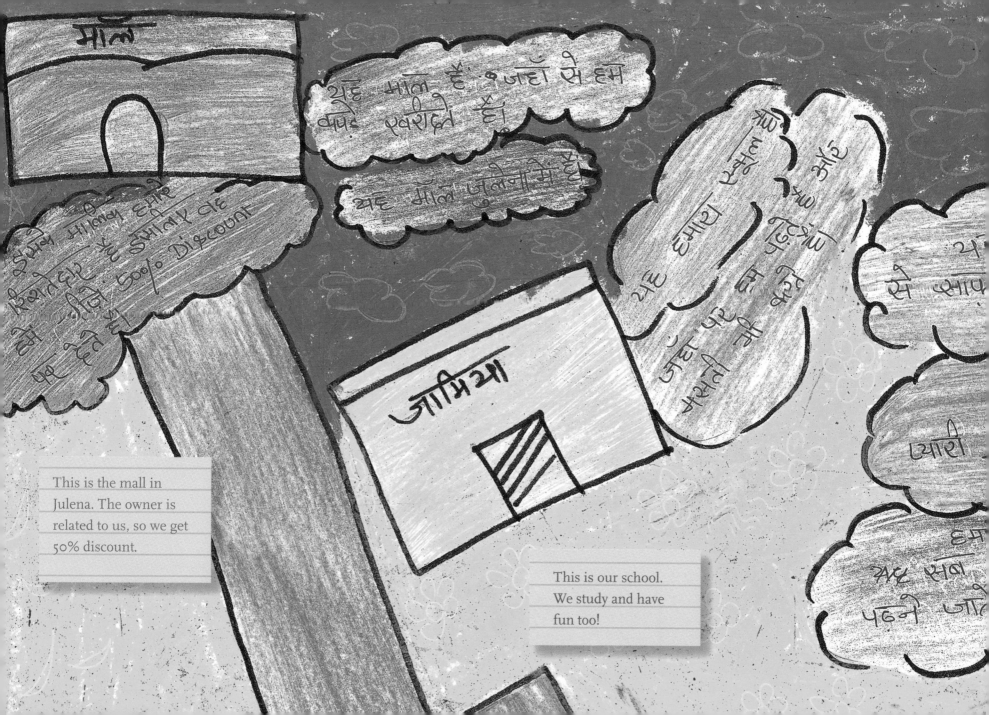

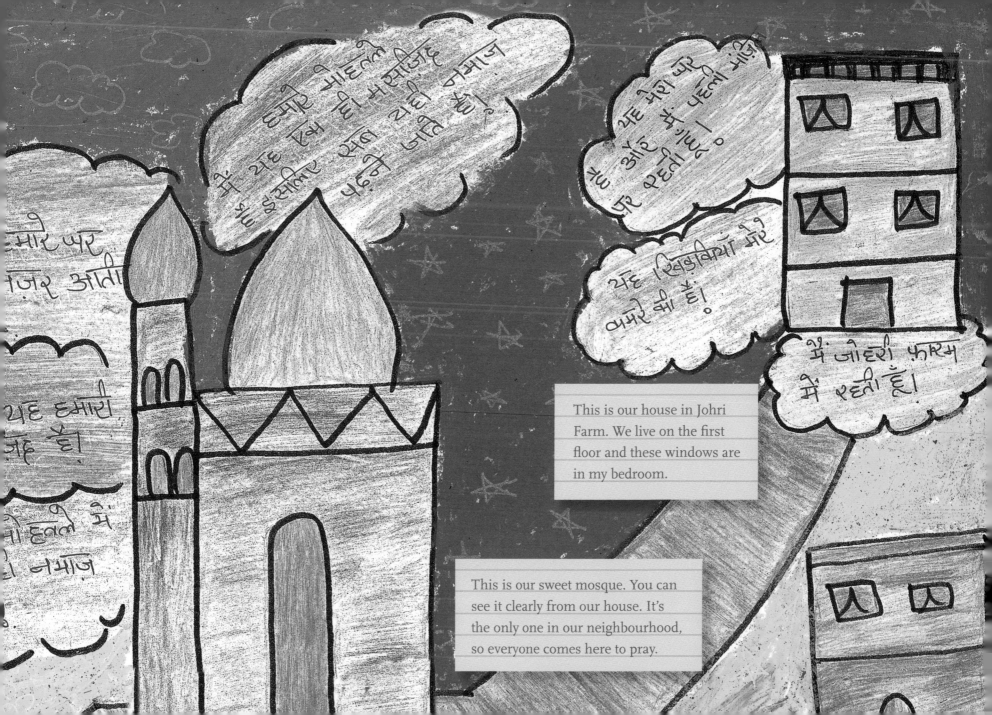

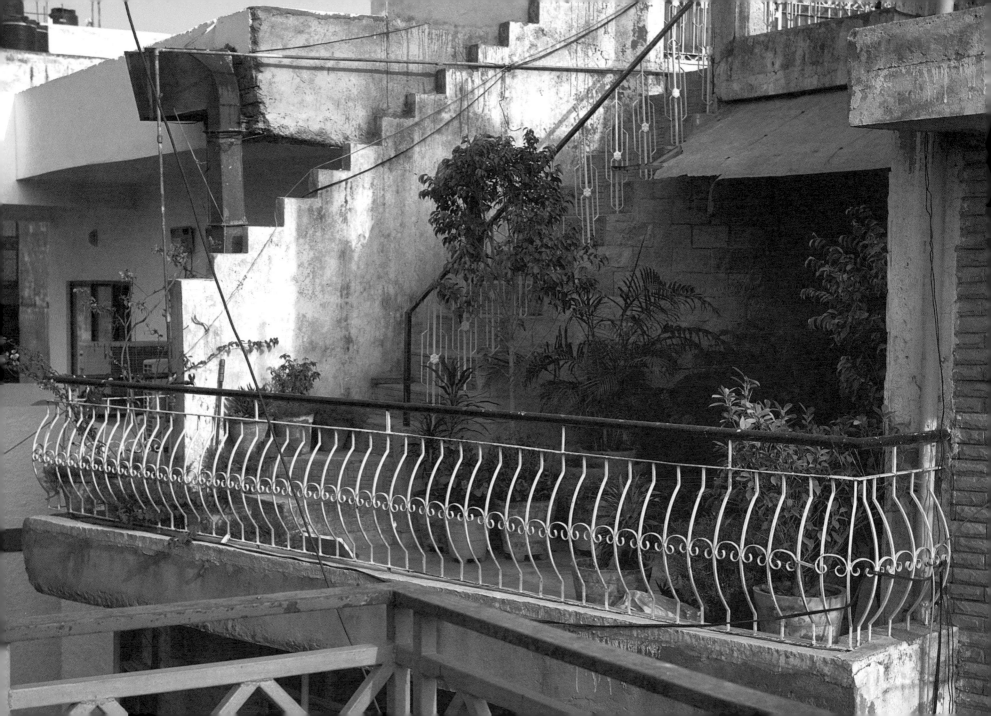

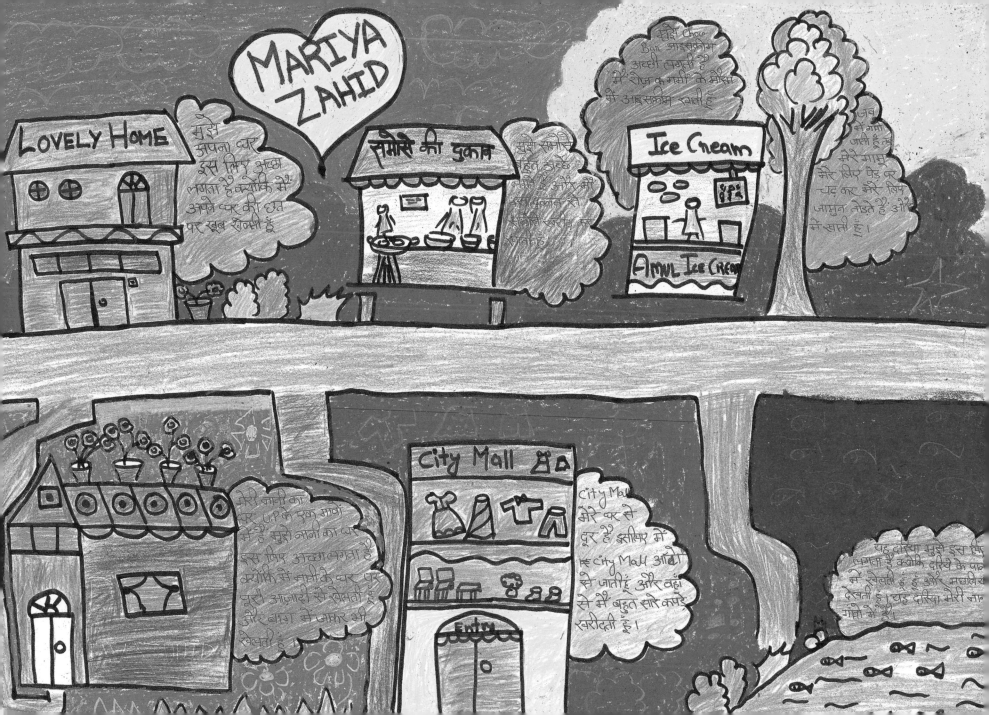

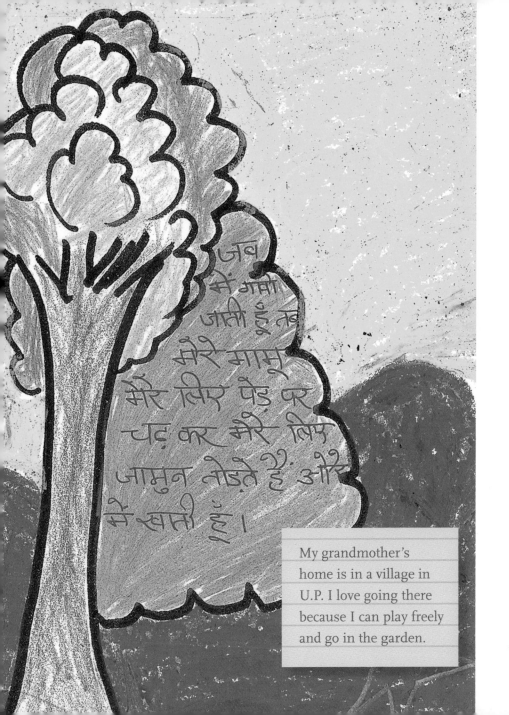

जब मैं गाँव जाती हूँ तो मेरे मामू मेरे लिए पेड़ पर चढ़ कर मेरे लिए जामुन तोड़ते हैं और मैं खाती हूँ।

My grandmother's home is in a village in U.P. I love going there because I can play freely and go in the garden.

I like to eat samosas. I eat samosas every evening. There is a shop near my house where samosas are made in the evening. They are made with potatoes and are light brown in colour. They are salty and I love eating them when they are hot. The uncle at the shop only makes them in the evenings, not in the morning. Sometimes, my mother also makes them at home. One day, when I went to buy samosas at the shop, I found that it was shut. I really wanted to eat samosas that day and when I saw that the shop was shut, I felt very bad. I went home and told my mother. She said, "You can eat them tomorrow." I went to my room and lay down on the bed. After a while, my mother came in. She had a plate of hot samosas that she had just made. I ate a lot of samosas that day.

Maria Zahid

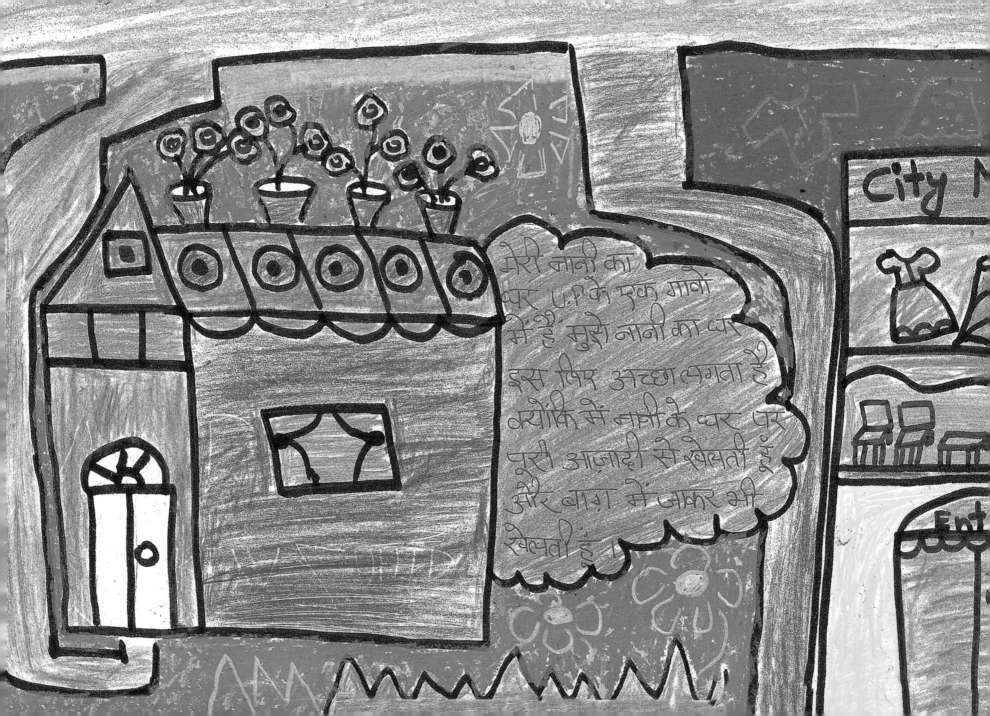

मेरी नानी का
घर U.P के एक गाँव
में है मुझे नानी का घर
इस लिए अच्छा लगता है
क्योंकि मैं नानी के घर पर
पूरी आज़ादी से खेलती
और बाग में जाकर भी
खेलती है

City M

Ent

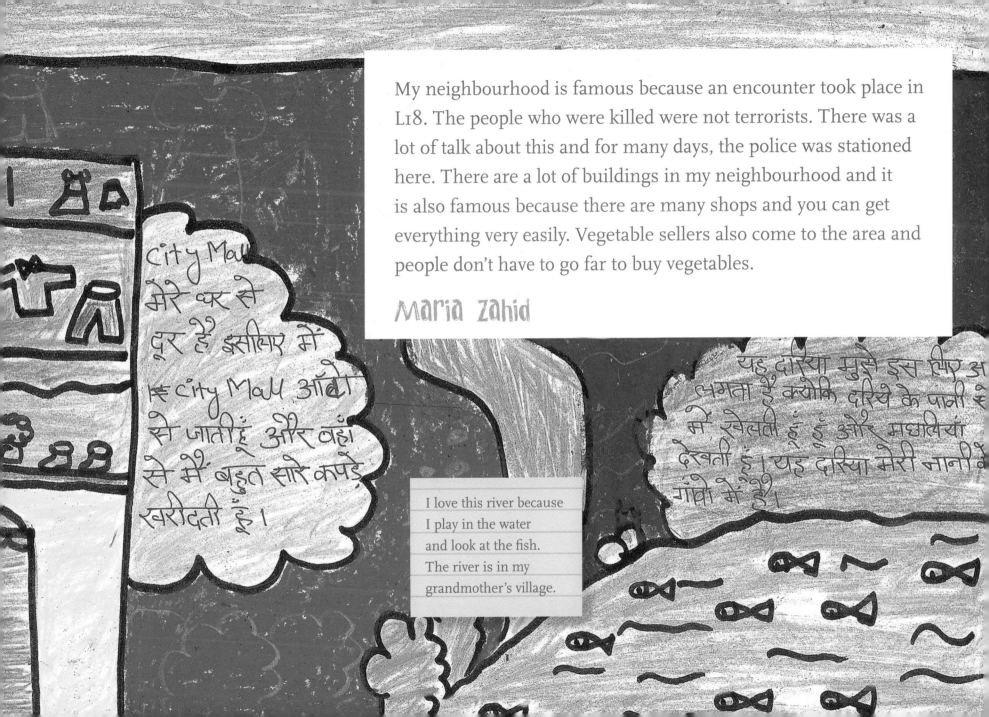

My neighbourhood is famous because an encounter took place in L18. The people who were killed were not terrorists. There was a lot of talk about this and for many days, the police was stationed here. There are a lot of buildings in my neighbourhood and it is also famous because there are many shops and you can get everything very easily. Vegetable sellers also come to the area and people don't have to go far to buy vegetables.

Maria Zahid

City Mall मेरे घर से दूर है इसलिए में =City Mall ऑटो से जाती हूं और वहां से में बहुत सारे कपड़े खरीदती हूं।

I love this river because
I play in the water
and look at the fish.
The river is in my
grandmother's village.

यह दरिया मुझे इस लिए अ भगता है क्योंकि दरिये के पानी में में खेलती हूं और मछलियां देखती हूं। यह दरिया मेरी नानी के गांव में है।

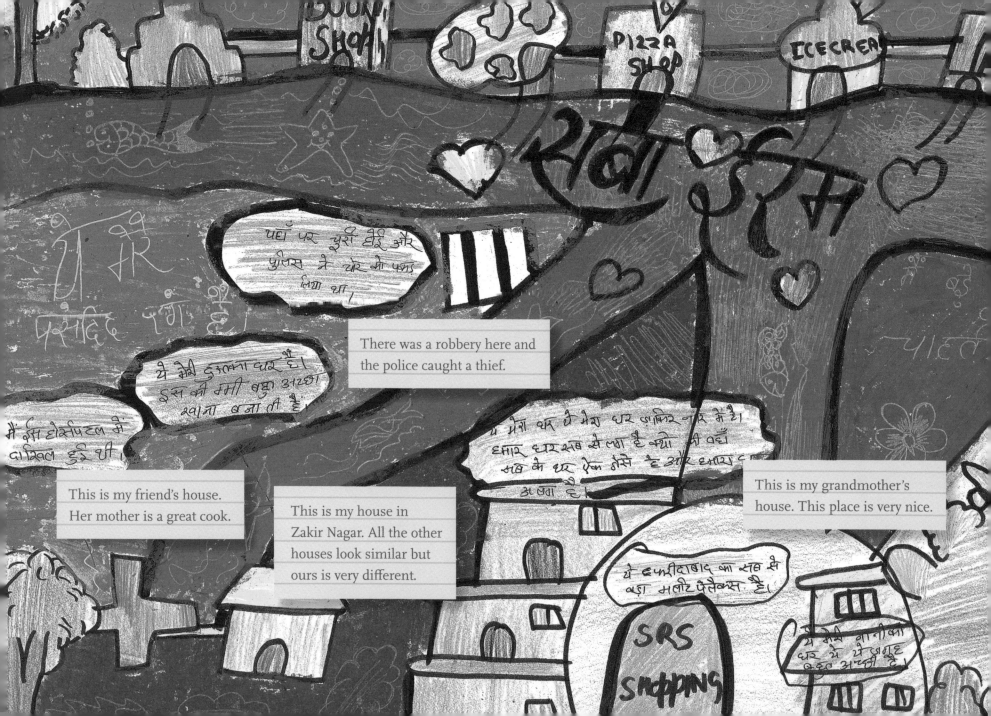

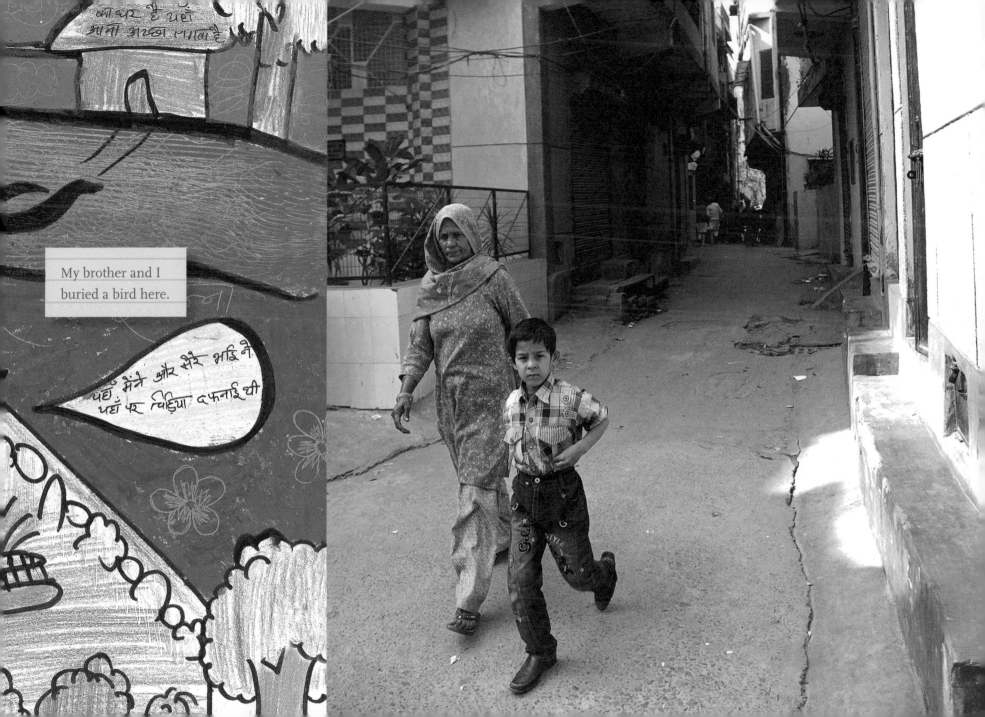

My brother and I
buried a bird here.

यहाँ मैंने और मेरे भाई ने
यहाँ पर चिड़िया दफनाई थी

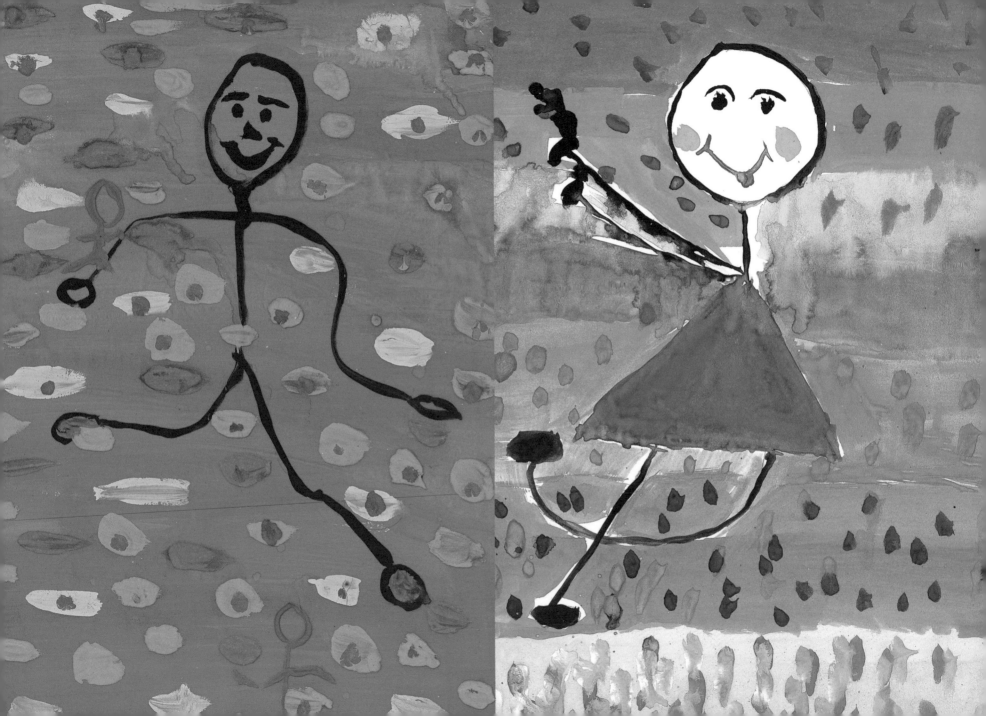

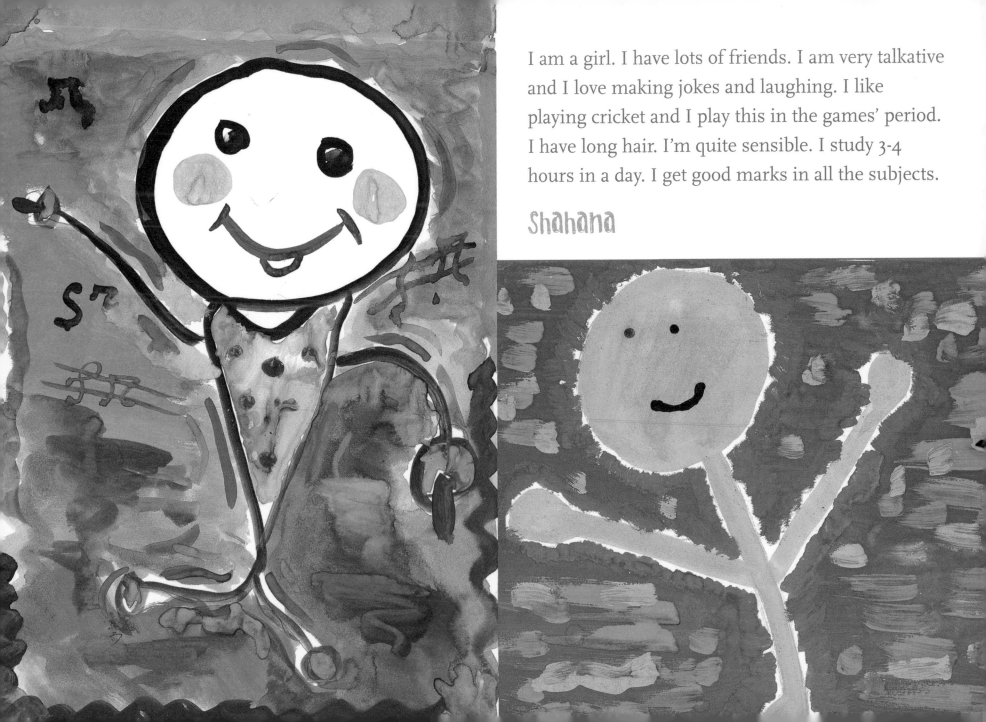

I am a girl. I have lots of friends. I am very talkative and I love making jokes and laughing. I like playing cricket and I play this in the games' period. I have long hair. I'm quite sensible. I study 3-4 hours in a day. I get good marks in all the subjects.

Shahana

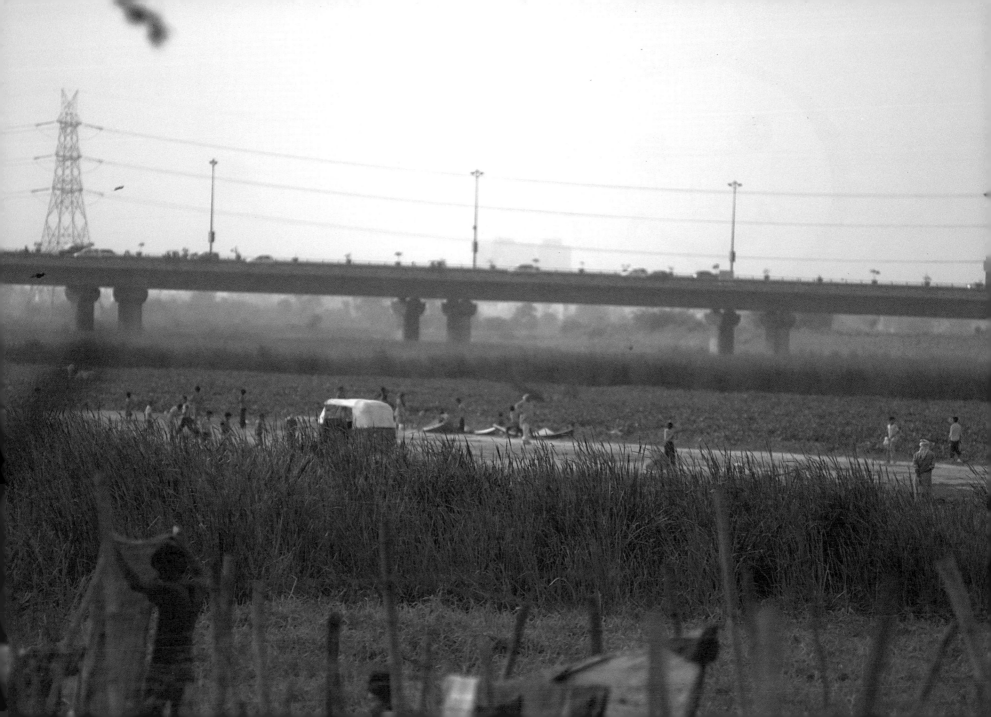

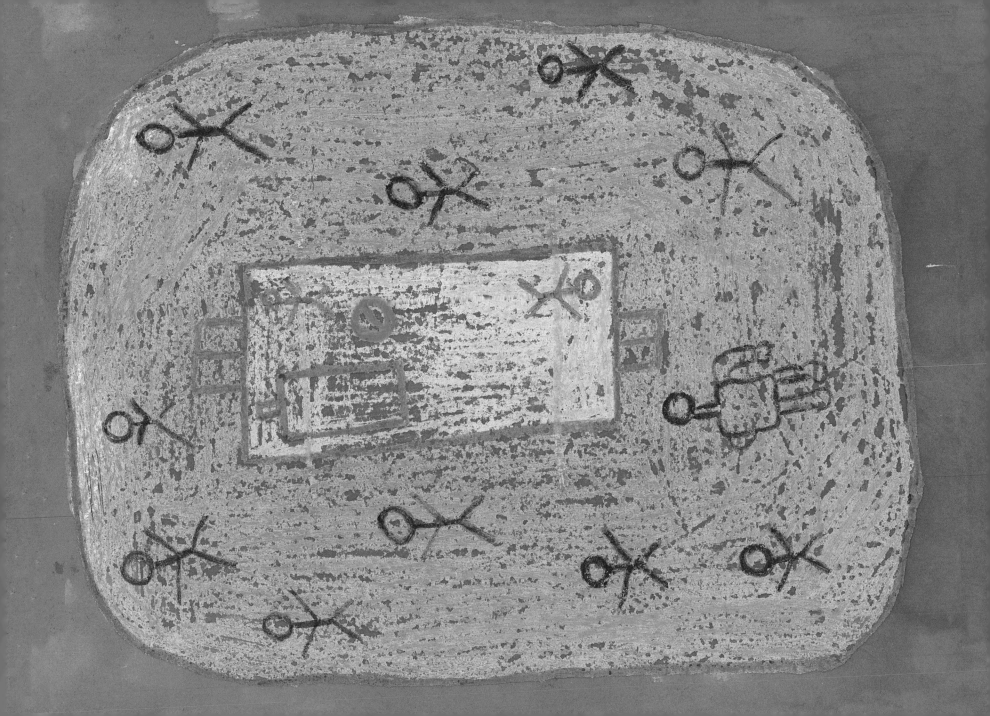

My name is Tabish. I like playing cricket. I play cricket with my friends on holidays. I like painting too. I am the opening batsman for my cricket team because I am a good batsman. When I grow up, I want to play for my country, India. I want to make my country, India, famous.

Tabish

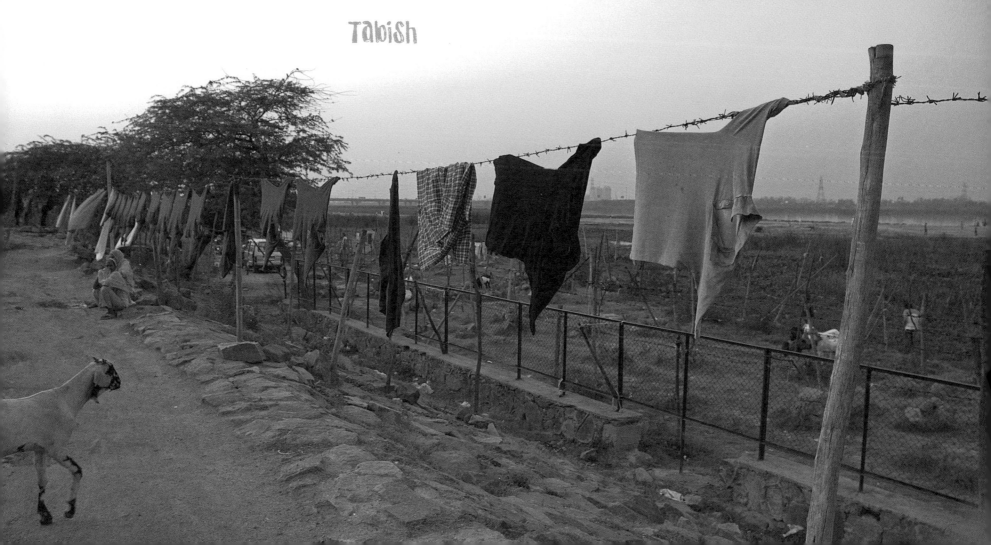

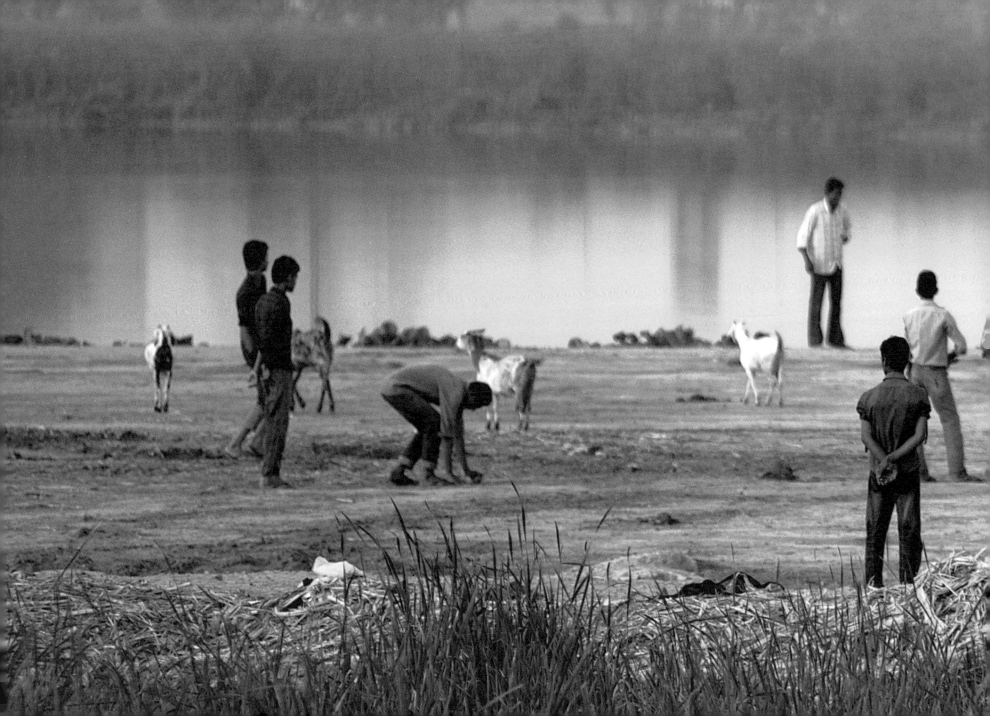

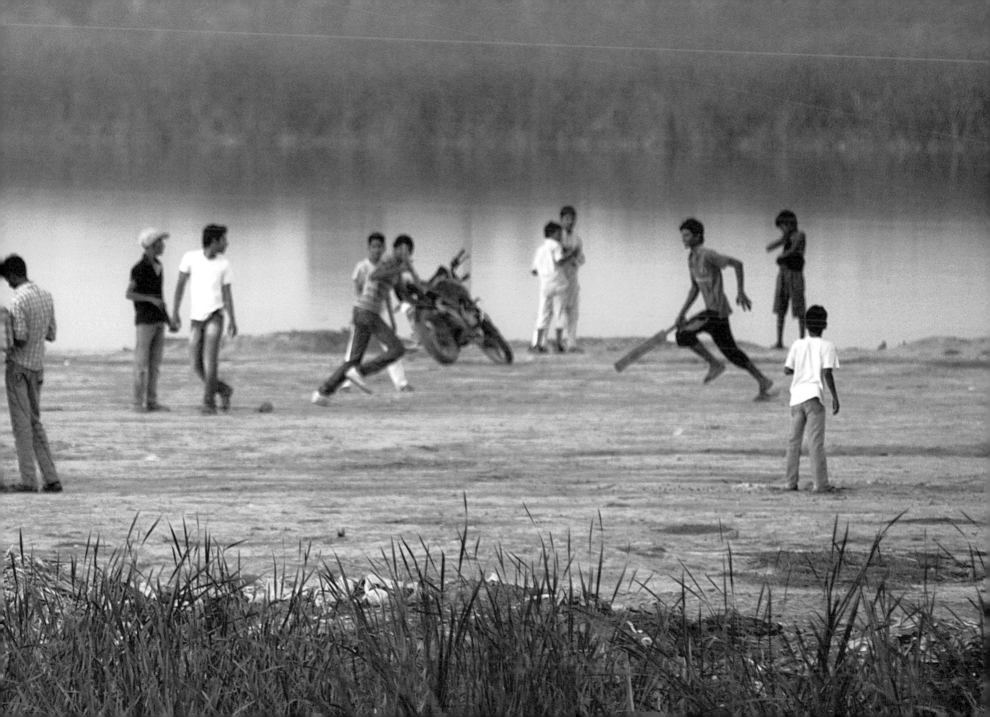

A game of cricket

Haroun watched the ball come straight at him. His sharp eyes had followed Yusuf's run up and had locked on to the ball as it was released. He could see it flying through the air, gathering speed. It was fast enough and straight enough to knock the middle stump down. But Haroun was ready. He put his right foot forward, held his bat straight and thwack! Bat and ball connected with force and as the ball went flying to the right, Haroun ran. By the time he reached the other side of the pitch, his teammates – Zakir, Ahsan and Zainab – were already cheering and the fielders were running in the direction of the river. It was a six. Yusuf smiled wryly as Haroun walked back to the stumps.

"Abbe, that was a big hit. We may have lost the ball."

"Sorry, yaar!" said Haroun, unable to contain his smile.

"I'll bet you are! Hey, Zakir, Ahsan, Zainab – go help my team look for the ball. Your batsman is making sure you guys don't get a chance to bat."

7-year old Zainab, Haroun's little sister and the youngest among them, began to chant, "I want to bat, I want to bat, I want to bat!" Haroun shushed her and told her to go look for the ball. Zainab ran off.

"I don't know why she wants to play cricket," he grumbled to Yusuf. "And why Ammi makes me bring her along."

"Arre, forget it, yaar. Sameer is the same age too," said Yusuf, "Listen, next week, there are trials for the school team. You should come, now that you're in the sixth. I'll tell the coach."

Yusuf was a year older than Haroun and had been part of the Jamia Middle School cricket team for the past one year. Haroun was thrilled that Yusuf thought him good enough to be a part of the team. The boys lived close to each other in Batla House and cricket made them friends. There was no park or empty space where they lived and in the beginning, they used to play on the terrace of Yusuf's building. As the boys grew up and more children joined them, the game spread to other neighbouring terraces. So, the batsman would stand on one terrace, the bowler would bowl from the neighbouring one and fielders would be posted on other surrounding terraces. Haroun and his friends knew a thing or two about how to find room to play in.

"How often do you have to stay back for practice?" asked Haroun. He could hear their friends shouting in the distance. The ball had still not been found. "At least three times a week," Yusuf said, "And every day when there's a tournament coming up." He turned towards the river. The sun was beginning to set. It was almost time to go home. "Let's go help them look for the ball," he said, "You really hit that one hard." The two boys headed in the direction of the lost ball. "Yaar, Ammi will not be happy if I spend all my time playing cricket," Haroun said, "You know she's very strict about studies."

"So? You'll have to manage it. You know Ahmed? In class eight? He is one of the best batsmen in the team and he also topped the class in science. Come on, you can't let that stop you."

They reached the tall elephant grass that grew at the edge of the river. The smell of stagnant water wafted through the air. The Yamuna was sluggish and grey here at Okhla but it did give the children a wide, open field to make into their cricket ground. "Much better than jumping across terraces," Yusuf's father

had said when the children had broached the subject of playing there in the evenings. And so, for the past few months, the river's edge had become their playing field.

"I see it, I see it!" Zainab's voice drifted out from the elephant grass. The sun had become a fiery orange ball, hanging low in the sky. Yusuf looked at Haroun and smiled, "Not so bad now, huh, her coming along?" Haroun made a face. "Let's see if she has really found it." Suddenly, there was a wail.

"Oh no, now what?" thought Haroun. Zainab came trailing out of the elephant grass followed by the others. In one hand, she held the ball and in the other, a small, limp bird.

"You killed it!" she looked at Haroun, accusingly. Haroun looked baffled. "Why are you crying?" he asked.

"She found the bird lying next to the ball," said Zakir, "It's been hit. It's dead."

"But how do you know it was the cricket ball?" asked Yusuf.

"It was, it was," said Zainab, "It was right near the bird and look, there's blood on her head." The children crowded around and examined the bird.

It was a munia, red with white patches on the chest. The eyes were shut and fresh blood oozed out from near its beak. Haroun looked at the bird and at Zainab's tear-stained face.

"I was only batting," he said, "It's an accident." "And a real freak one," he thought to himself. He knew birds got hit during cricket matches. He'd seen videos on YouTube. But, here, in Okhla! In the elephant grass! He shook his head in disbelicf.

"Forget it, Zainab" said Zakir, "It's just a bird."

"But it's dead now. And it's because of us." Zainab started wailing again.

The *maghrebazaan* (call for the prayer after sunset) burst through the loudspeaker of the mosque nearby. The children started leaving. Yusuf looked at Haroun and said, "Come on, let's go." But Zainab was sobbing over the bird.

"You carry on. I'll bring her in a bit," said Haroun, quietly. Yusuf left and then it was just the brother looking on helplessly at his younger sister.

"Zainab, I didn't mean to hit it," he began, "You know, these things happen. I'll show you a match on YouTube where a pigeon got hit."

Zainab looked up, "But that doesn't help this bird!"

"Yes, but what can we do now?" The last of the *azaan* (the Islamic call for prayer) dissolved in the breeze and the sun melted into the sky, turning it pink.

"Come on, Ammi will start worrying. We have to go home." The crickets chirped. The wind picked up. And Haroun waited. He looked towards Batla House and noticed a girl, not much older than him, standing at the spot where the road ended. She was wearing a white school skirt and blouse and had a schoolbag slung over her left shoulder.

"I know," said Zainab, "I know what we can do. We can bury her."

"What!"

"Yes, that's the least that we can do." Zainab stood up and faced her brother, squarely. "We can bury her and say the *fatiha* (a prayer for the mercy of God) over her grave."

Haroun rolled his eyes but he saw the determined thrust of Zainab's chin. He looked around and saw a stick lying on the ground. "Alright," he sighed,

"Let's get this over with." Silhouetted against the fading light, the brother and sister dug a shallow grave, placed the bird in it and covered her with earth. Haroun stood politely, while Zainab said the *fatiha* as she remembered it. Perhaps, the girl was watching them. "We must look so silly," he thought. Zainab slipped her hand into Haroun's. "We can go now," she said. Haroun turned towards the road. The girl had gone and Haroun led Zainab home.

जब हम लोग मंच हार जाते हैं तो मुझे बहुत दर्द होता है

MOHD FAIZAN Saifi

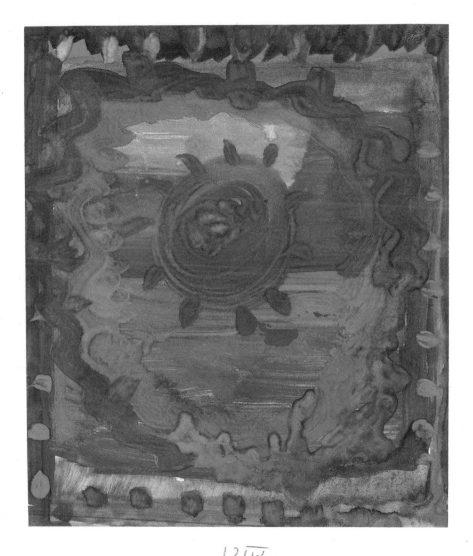

प्यार

मुझे जानवर बहुत पसंद हैं क्यों की वह
बहुत प्यारे होते हैं।

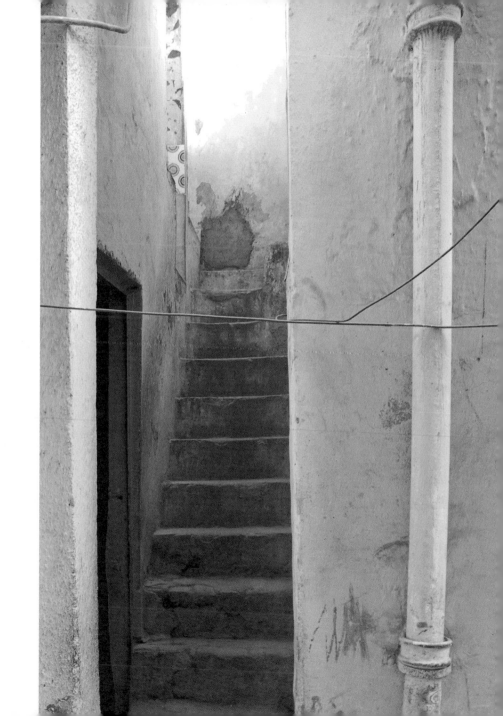

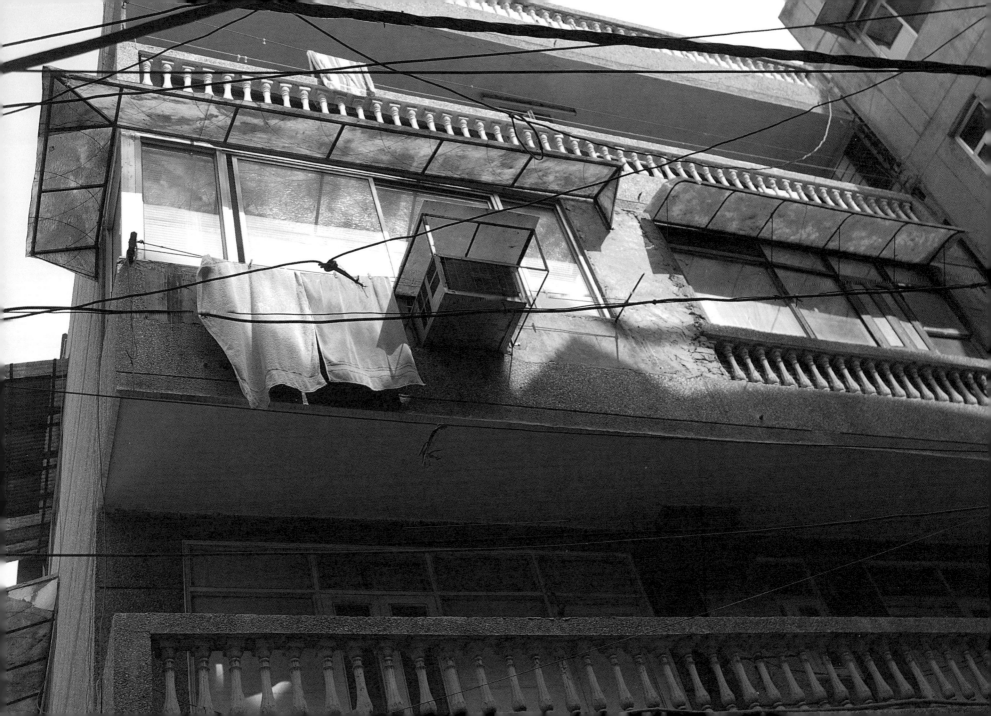

My home is in Jamia. I live there with my brother, sister and my parents. Our house has three rooms. We have a guava tree in the courtyard that allows very little sunlight to filter in during the winter. In front of our house, there is a road and just across it is a workshop. The workshop is at work all the time and the noise from there travels to my house, all the time. At a short distance from my house is a mosque from where we hear the *azaan*, five times a day. At night, we can hear the dogs barking outside. There is a school in front of my house and that's where I study. Getting to school is no problem! There's also the Jamia College dispensary in front of the house and a garden with fountains. Some distance away, there's a small market where I go with my father to buy things.

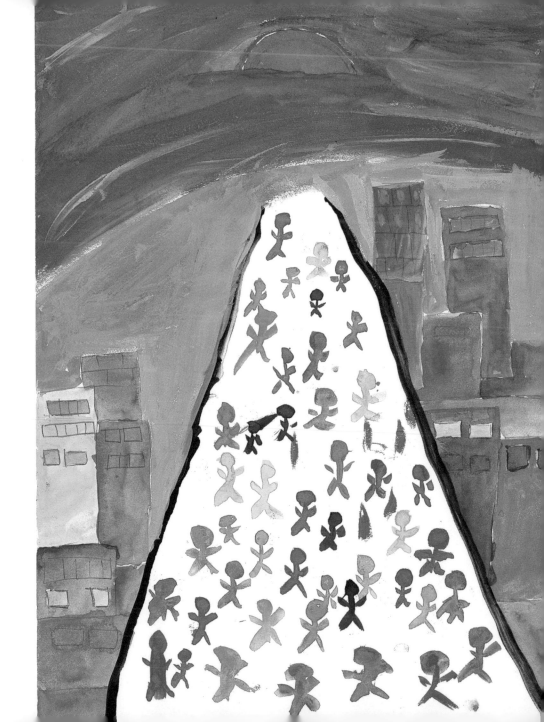

The terrace of my house is full of dried leaves, so I rarely go up there. On holidays, I go to the Jamia field to play with the neighbourhood children but the guard chases us away. The front of the house has been turned into a car park and even on holidays, there are cars parked here. Looking at them, I feel angry.

There's no room to play! We have to play in a narrow alley behind my house. It's not very good to play in and frustrated, we often stop after a while.

I like my house very much.

Shan e Haider

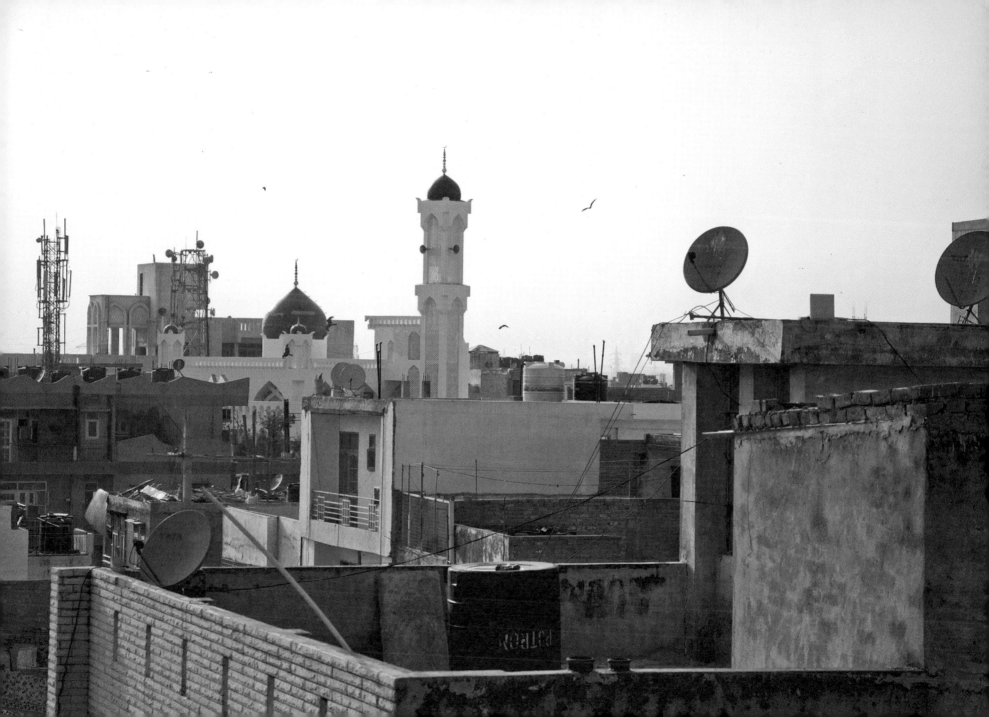

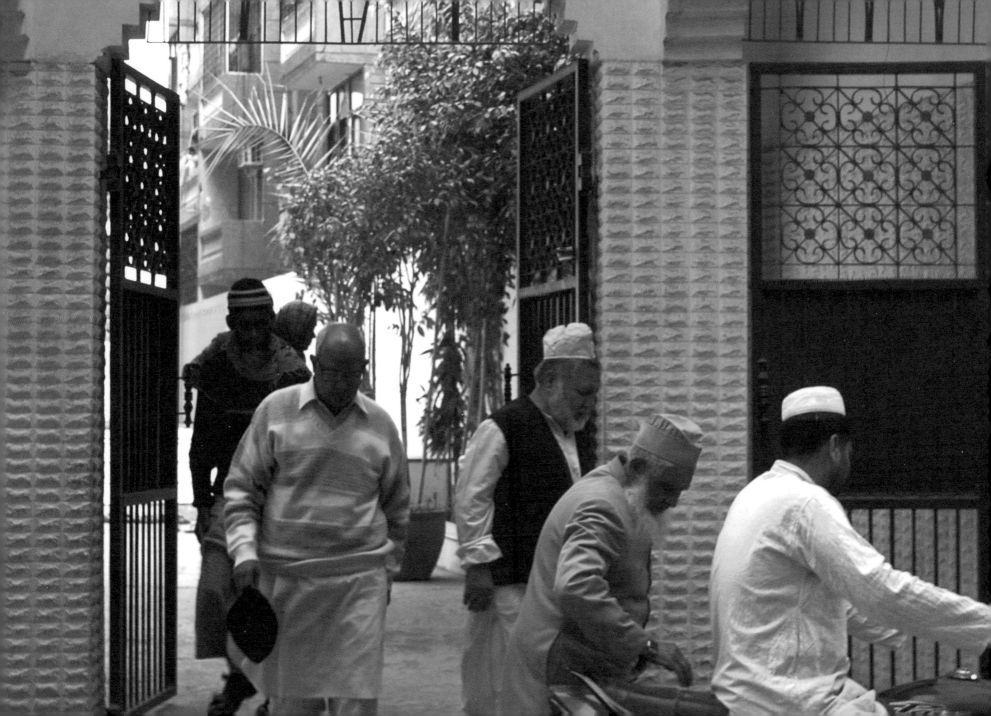

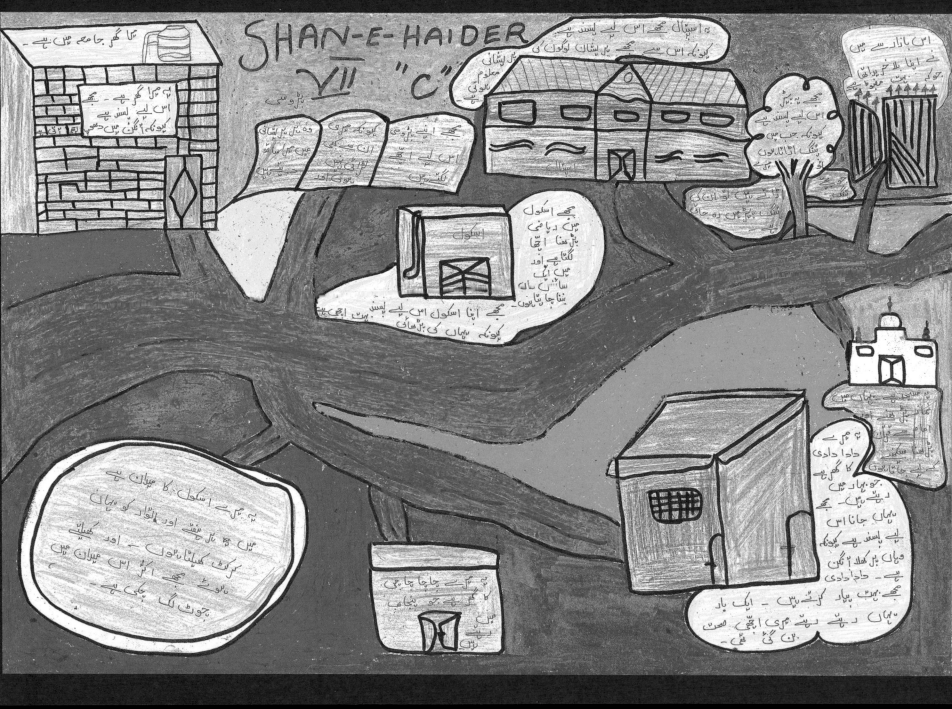

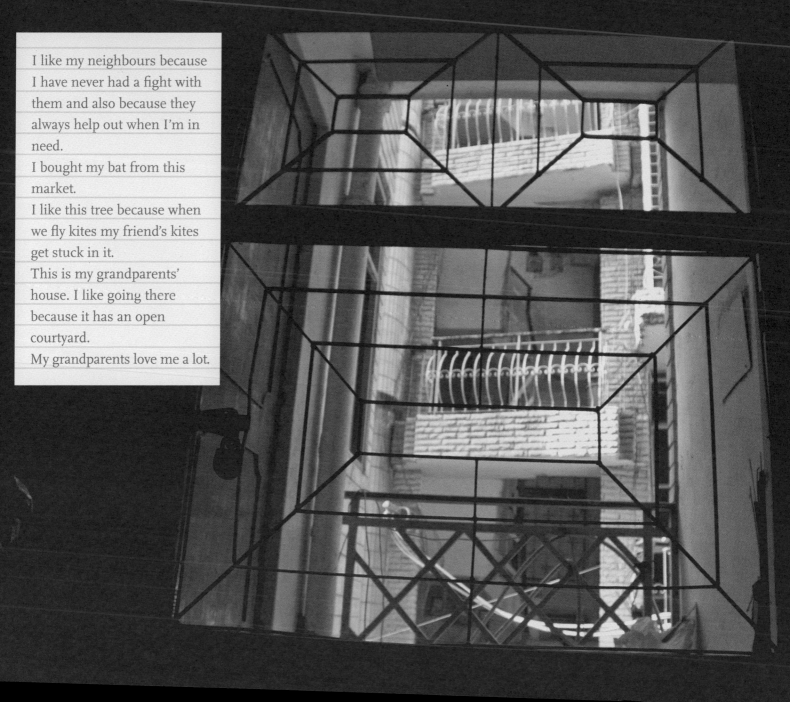

I like my neighbours because I have never had a fight with them and also because they always help out when I'm in need.
I bought my bat from this market.
I like this tree because when we fly kites my friend's kites get stuck in it.
This is my grandparents' house. I like going there because it has an open courtyard.
My grandparents love me a lot.

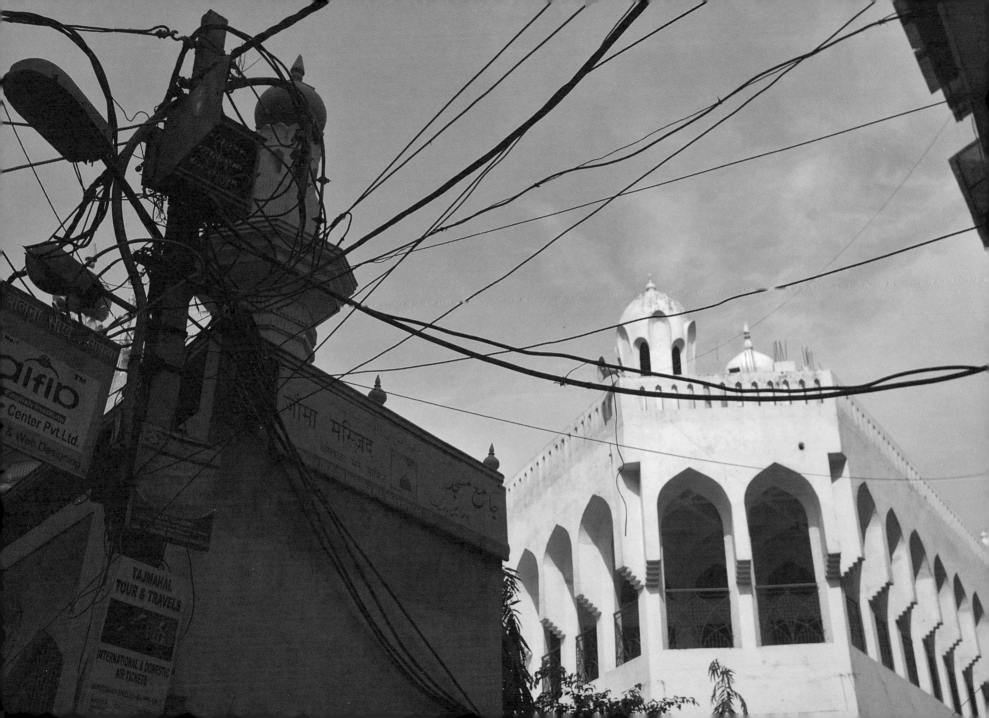

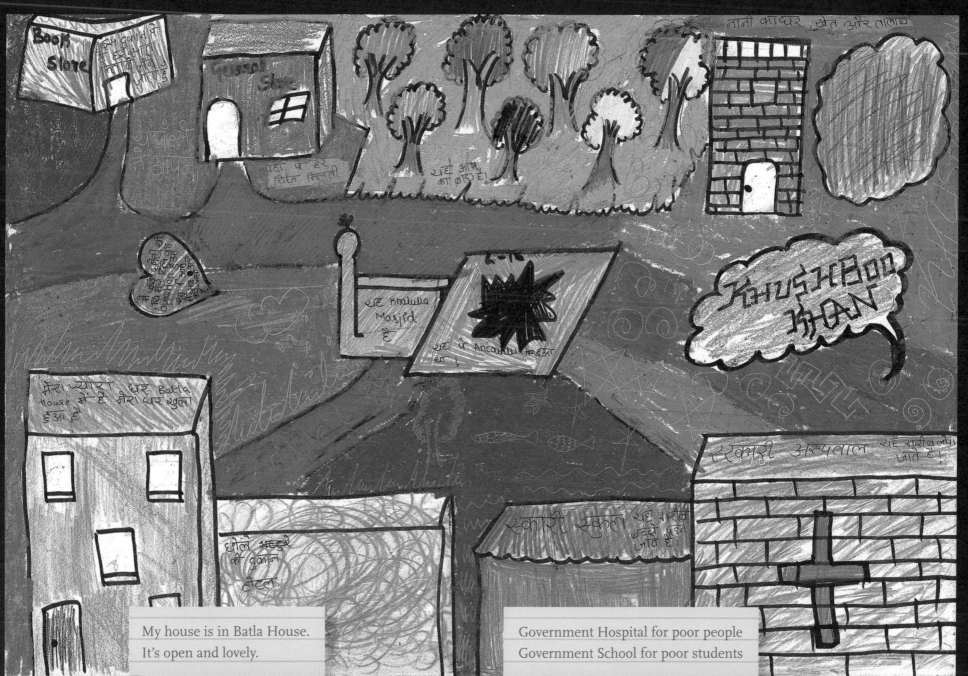

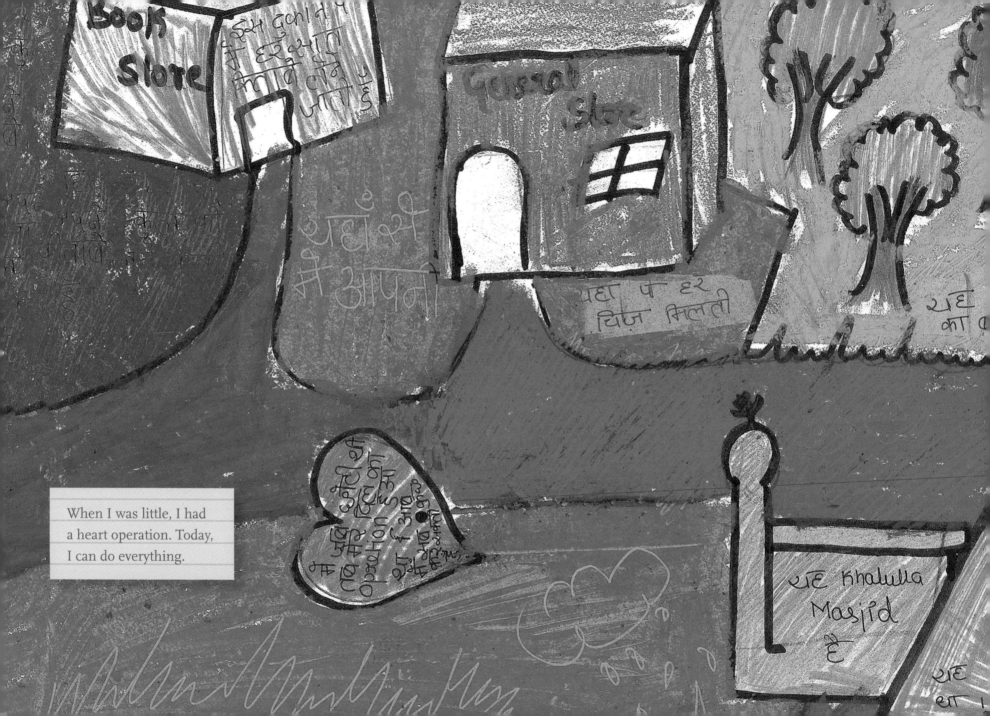

When I was little, I had a heart operation. Today, I can do everything.

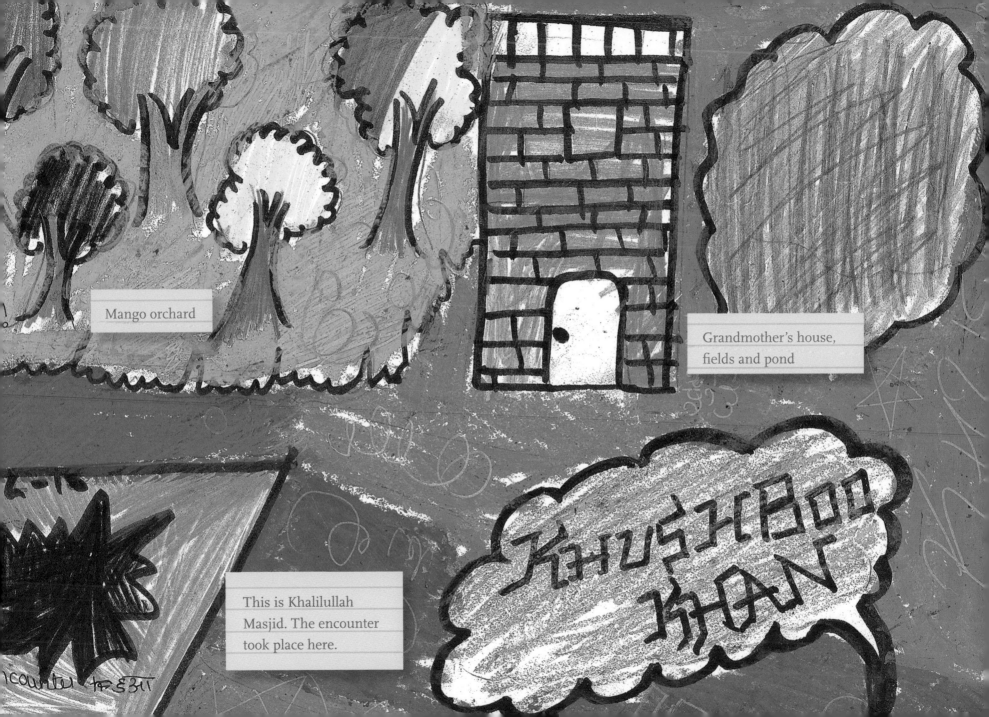

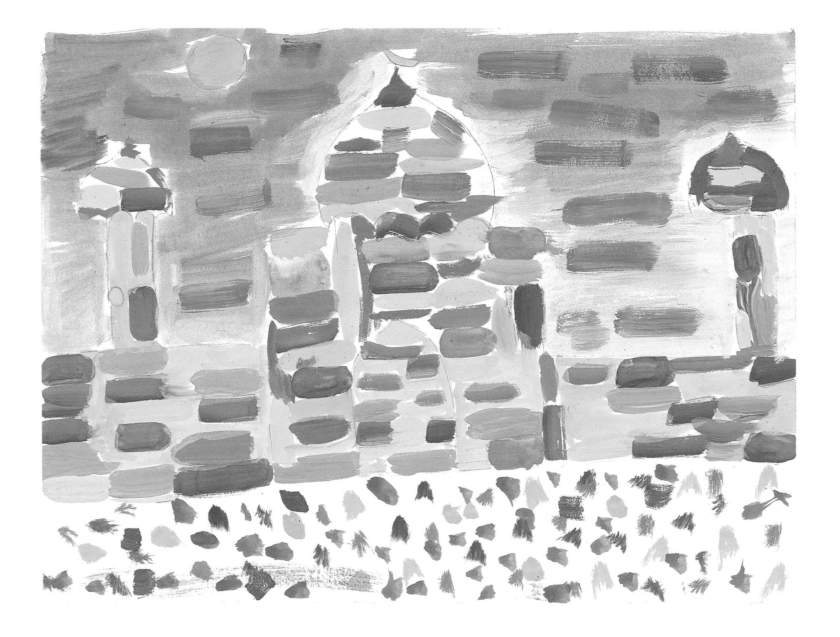

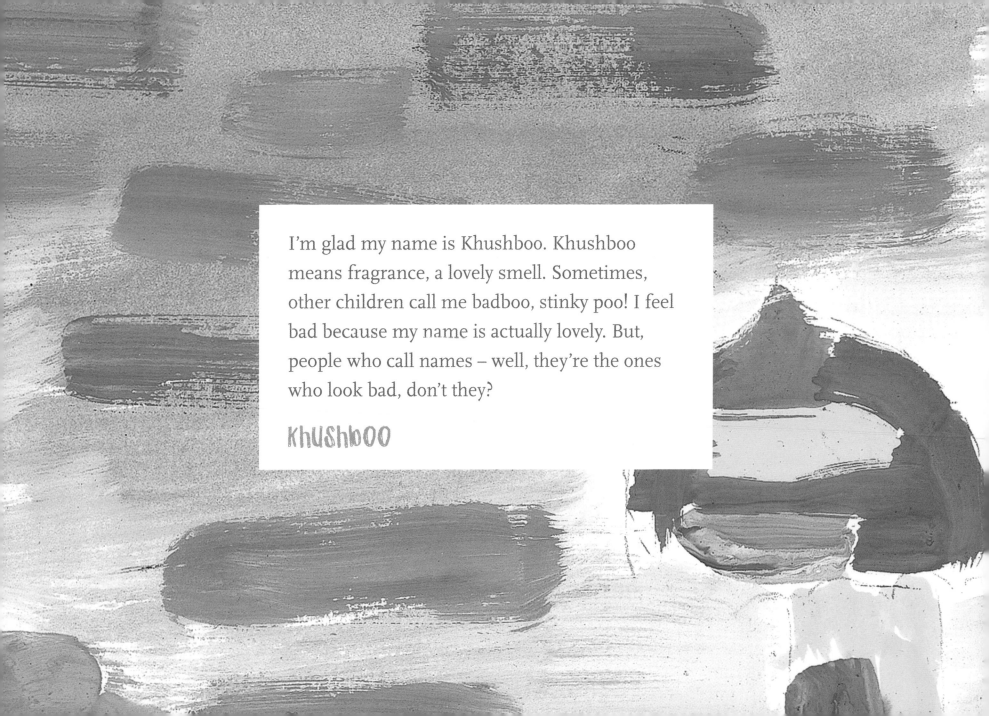

I'm glad my name is Khushboo. Khushboo means fragrance, a lovely smell. Sometimes, other children call me badboo, stinky poo! I feel bad because my name is actually lovely. But, people who call names – well, they're the ones who look bad, don't they?

KhushbOO

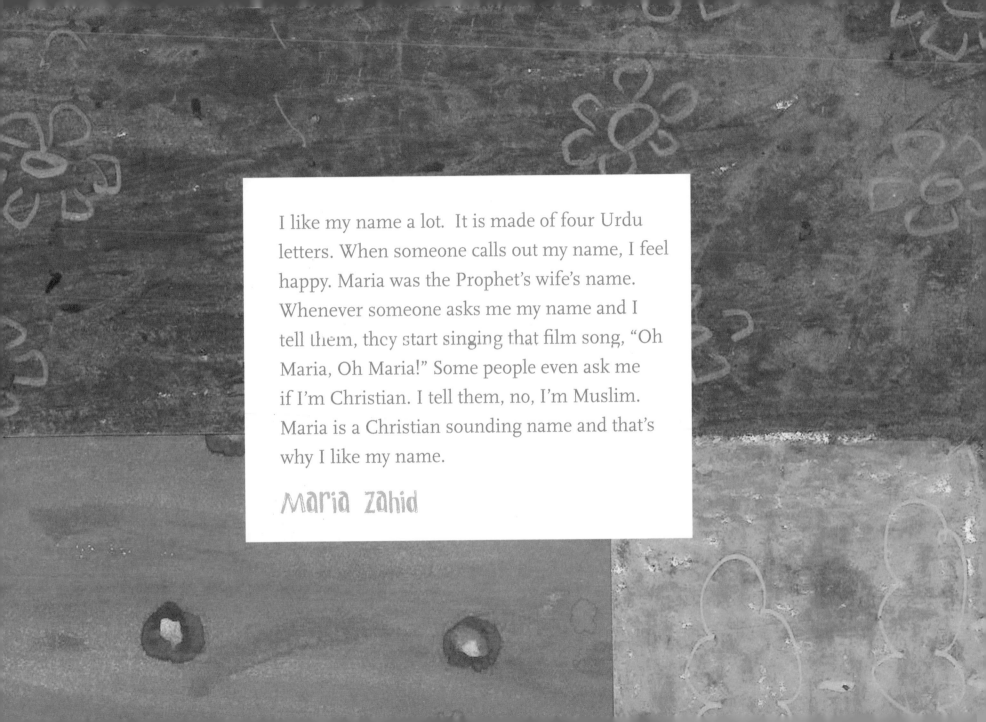

I like my name a lot. It is made of four Urdu letters. When someone calls out my name, I feel happy. Maria was the Prophet's wife's name. Whenever someone asks me my name and I tell them, thcy start singing that film song, "Oh Maria, Oh Maria!" Some people even ask me if I'm Christian. I tell them, no, I'm Muslim. Maria is a Christian sounding name and that's why I like my name.

Maria Zahid

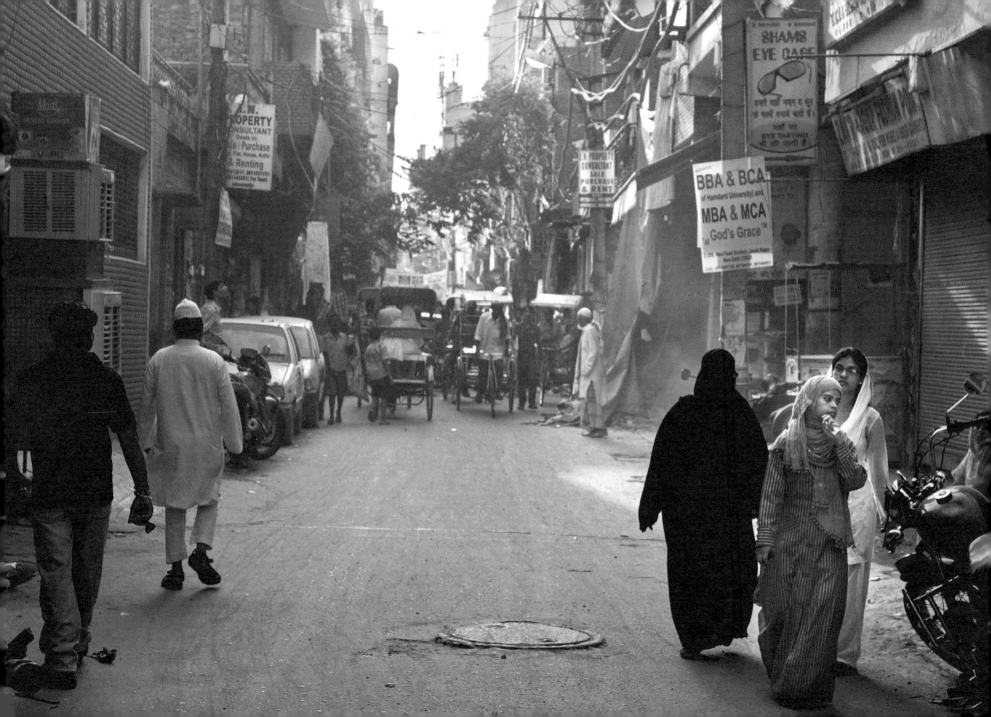

My name is Abu Bakr and I like my name a lot because my grandfather kept it for me with a lot of love. My roll number in class is always Number One because my name begins with A. Even in exams, because of my roll number, I stay ahead in many things. Abu Bakr was the name of the Prophet's best friend and the first Caliph. He did many good deeds. When children tease me about my name, I tell them that Abu Bakr was the name of a great Caliph. Then, they stop teasing me. When I hear Hazrat Abu Bakr's name, I feel proud that I share the same name with him.

Abu Bakr

٧٨٤

احمل حسین خاں

ڈاکٹر عاصمہ حسین

A.H.KHAN

Dr. ASIMA HUSAIN

I like my neighbourhood a lot. There is a road in front of my house and a barber's shop and a doctor's shop next to it. These are very useful. My neighbours are very nice and are part of our joys and sorrows. The road in front of my house is busy with cars. Hawkers come by, selling vegetables, fruits, toys and clothes. It is so busy that we don't open our windows because they face the road. There is a *masjid* near my house and when we hear the *azaan*, my mother says her prayers. There are a lot of plants on the terrace and I water them. At night, we can hear the dogs barking and planes flying above. We have a nameplate at the gate that has the house number and my mother's name on it so people can find our house. My friends in the neighbourhood all have their father's names on the nameplates. I feel happy that my nameplate is different from theirs.

Shahana

SAEED VILLA
295, STREET No-2
ZAKIR NAGAR
NEW DELHI-25

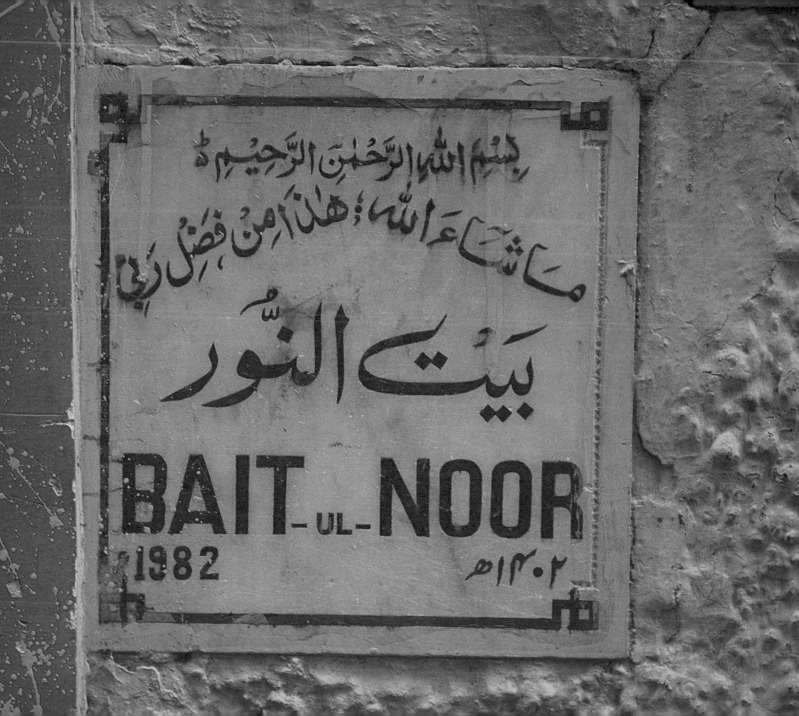

بِسْمِ اللهِ الرَّحْمٰنِ الرَّحِيمِ

مَا شَاءَ اللهُ هٰذَا مِنْ فَضْلِ رَبِّي

بَيْتُ النُّور

BAIT -UL- NOOR

1982 ۱۴۰۲ھ

A new nameplate

Yasmin opened the terrace door and stepped out. The sky was pink and the plants arranged all around the terrace were bobbing in the breeze. She took a deep breath. The air was full of the Yamuna but at least, she was out in the open. The house was crowded with relatives. The *milad* (community prayer to remember the Prophet Muhammad) had finished and people were saying their *namaz* (the ritual prayers prescribed by Islam). Soon, it would be time to help with the dinner, the clatter of dishes and the voices saying "What a brave girl!" She didn't want to hear that one more time. She sighed. For now, there was the terrace, the pink sky, the breeze and solitude.

Yasmin couldn't believe that it had been a year since Abba had died. So much had happened. The blur of the first few weeks after Abba's heart attack, her final exams, Afshan getting typhoid, Nani coming to stay with them and Amma getting a job. And the nameplate on the gate...

Yasmin remembered the day it had been changed. She had returned home from school just as Nani was paying off the workman who had repainted the

wooden nameplate. Begum Noor Hussain, it said now. "But why?" she had screamed, "Why can't Abba's name stay?" Nani's eyes had filled with tears and she had stretched out her arms towards Yasmin. "Beta, come here." But Yasmin had pushed her away and locked herself in the bedroom. Amma had come home in the evening and explained to her that it was a formality for their bank loan. "You know, we will never forget him," she had said, "Even if his name is removed from all the papers, he will be in our hearts. You will always remember him, Yasmin, and you will always love him." She had cried then and Amma had cried with her. Yasmin realised then how much Amma needed her help, especially with Afshan. So, she had dried her eyes, hugged Amma and called out to Afshan and Nani. She had led them outside into the lane and they had all looked at the freshly painted nameplate. Afshan had run down the lane and come back panting, "It's the best one, Amma," she had said. "Really! And why is that?" Amma had asked. "It's the cleanest, with the neatest writing, and the only one with a mother's name on it," Afshan had declared, triumphantly. Amma

and Yasmin had exchanged a smile. What an observant 7 year old, Yasmin had thought. Amma had treated them all to orange ice-cream bars and Yasmin had gone to bed feeling better.

It made her feel better, even now, thinking of that day. Of course, she would manage. She would find Amma and Afshan, give them a hug and then smile sweetly at the next person who said, "What a brave girl!" Yasmin felt a smile curving her lips. Grown-ups were strange. They meant to help but really, they had no idea. She looked down at the black iron gate. It was an ordinary sort of gate in front of an ordinary sort of green one-storey house. But, even the gate had soaked in memories, thought Yasmin. When she had been younger, she had used the gate as a swing. She would hang on to it and Abba would push the gate open and then close. Open and close. The gate would creak and Yasmin would laugh. "Faster, Abba, faster!" Afshan never got a chance to do that, she thought. Yasmin closed her eyes and felt the lump form in her throat. Tomorrow, I will give her a ride on the gate, she told herself. She could hear

the *bawarchi*s (chefs) bringing in the *degh*s (a metal cooking utensil) of biryani and korma and Amma telling them where to arrange the food. She should go down and help, thought Yasmin.

She opened her eyes. The breeze had lifted a bit and a kite bobbed into view. In the distance, children trying to cut each other's kite strings shouted out. A pariah kite circled overhead. Lights had started to come on and they glittered against the pink of the sky. Yasmin spread her arms out and turned in a circle. She moved slowly, almost as if she was a bird gliding on the thermals. As she turned to face the road in front of the house, she saw a girl in a school uniform with a bag slung over her shoulder walking past. The girl looked up and their eyes met for a second. Yasmin smiled and wondered if she looked silly, with her arms outstretched in the wind. The girl smiled and walked away.

"Baji, what are you doing?" asked a small voice. It was Afshan, standing in the terrace doorway. Yasmin gestured for her to come close. "Have you ever wanted to fly like a bird, Afshan? Come, spread your wings and fly!" The two girls giggled and with their arms outstretched, turned slowly in the wind.

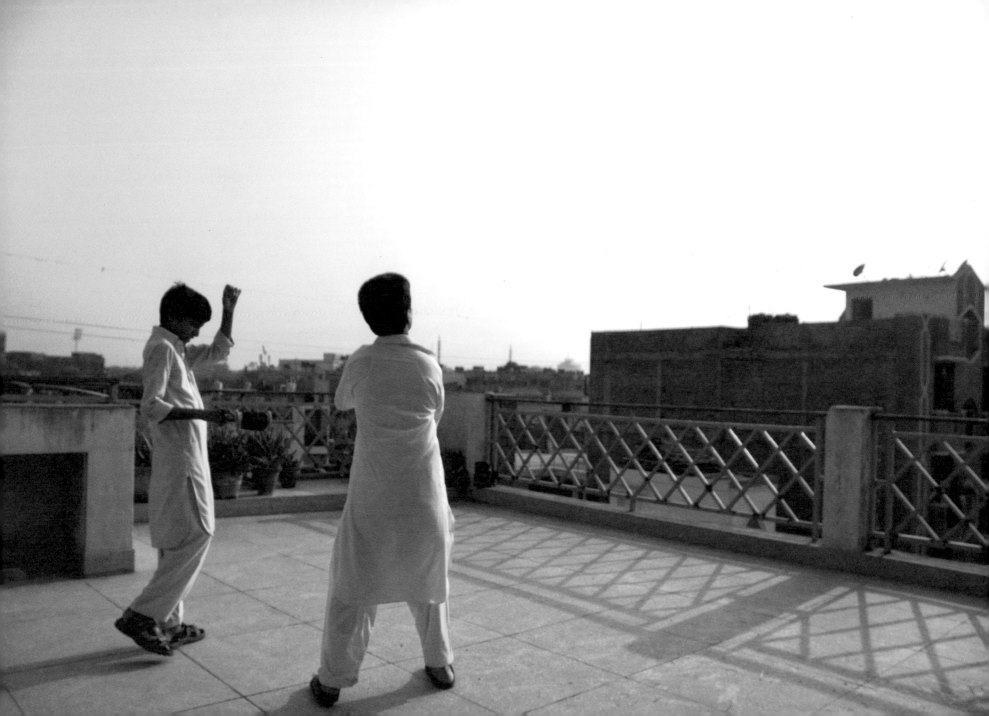

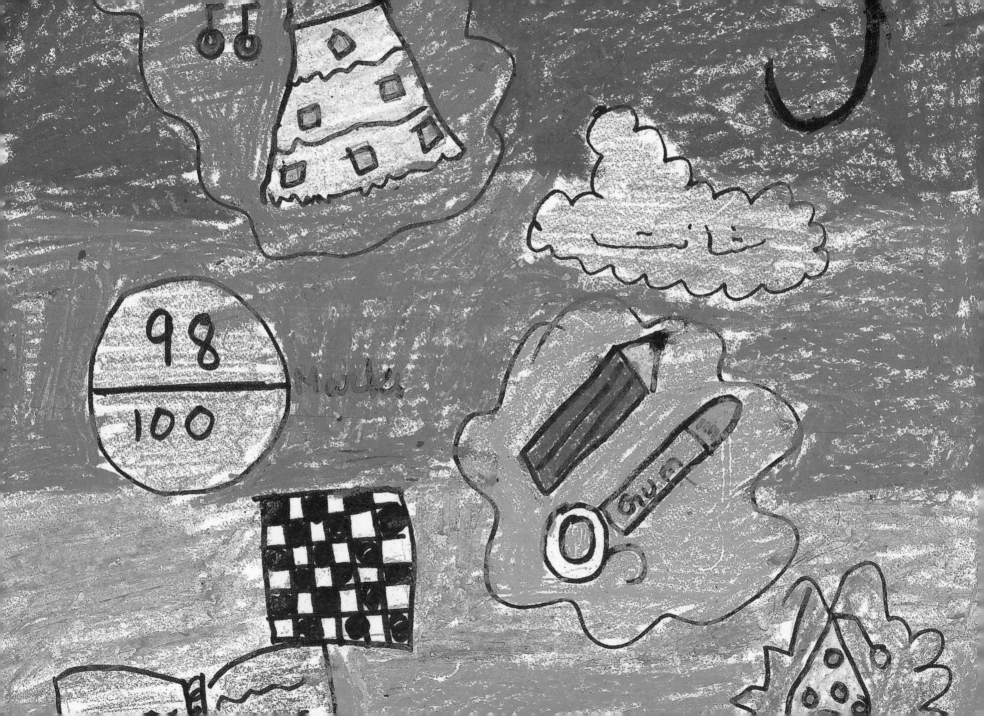

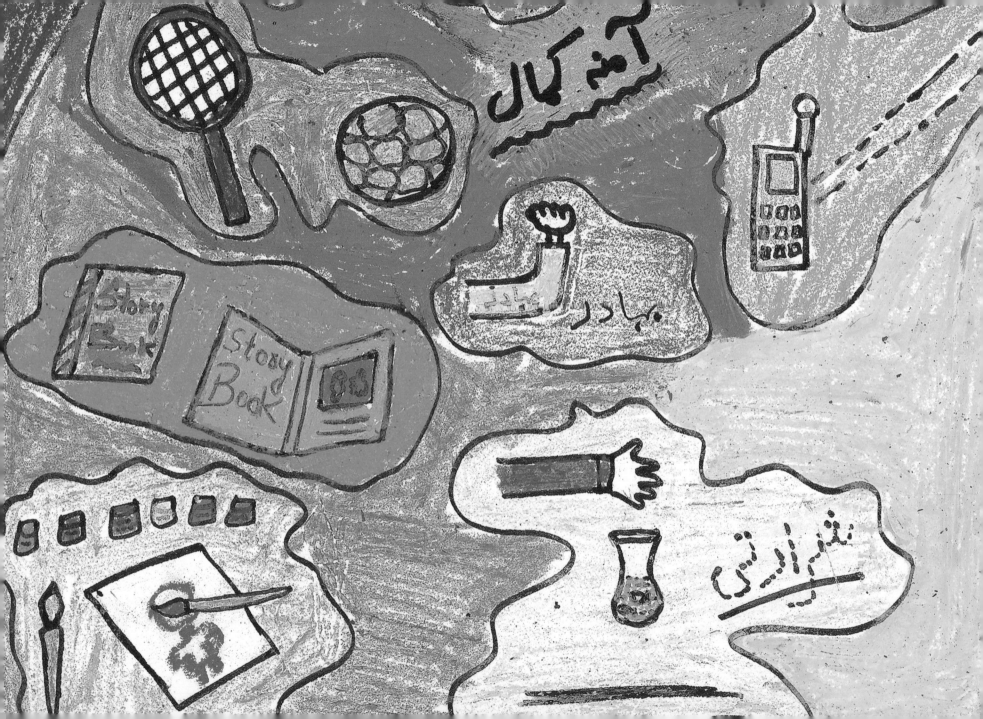

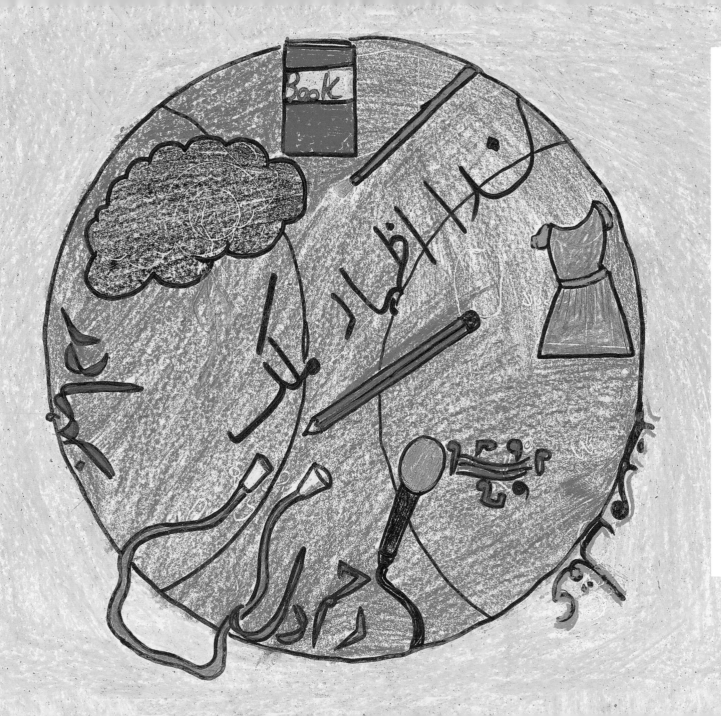

I wish my name was Alma or Mariam because Alma means wealthy with knowledge. When I hear this name, I think that perhaps people with this name are actually wealthy with knowledge. That's why I like it. There is a girl in my class called Alma but she gets bad marks. So, I wonder about it.

Nida

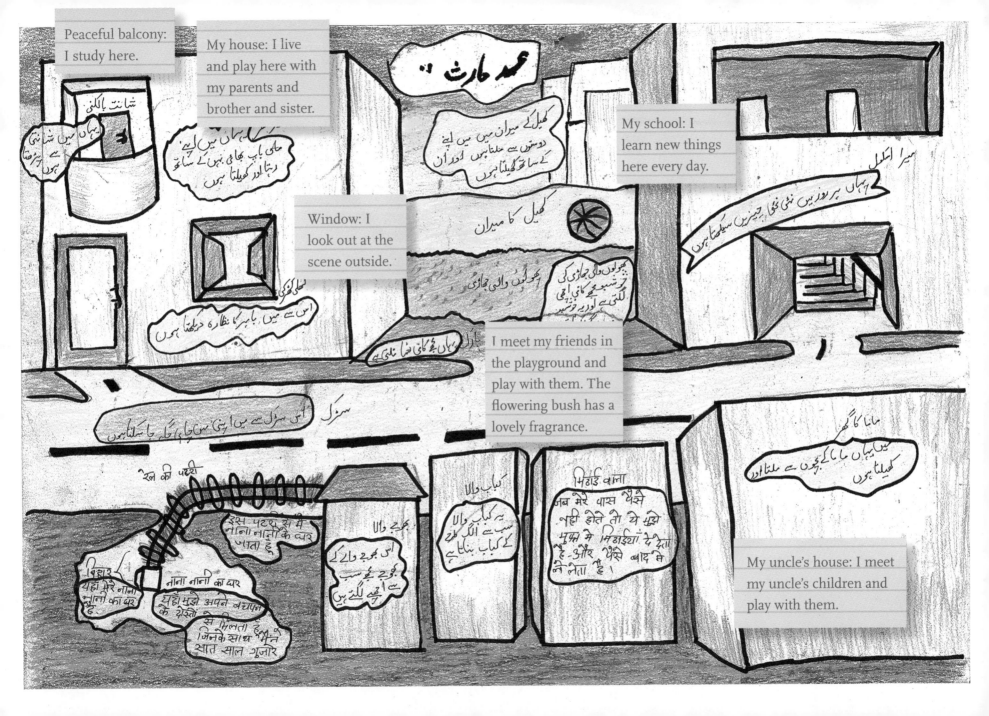

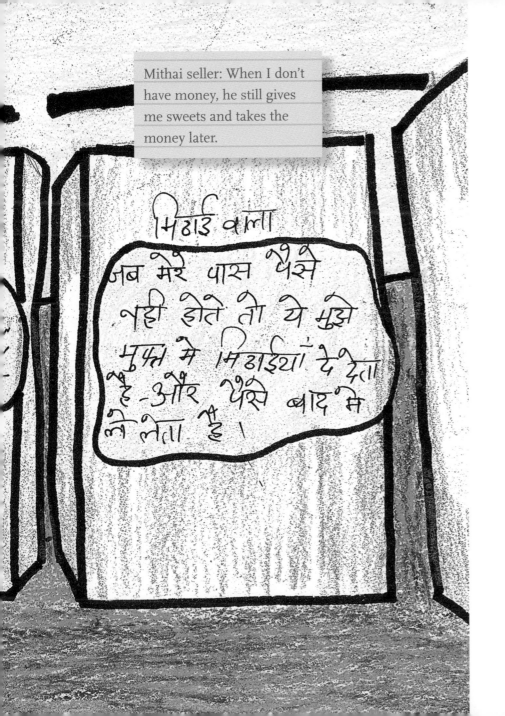

Mithai seller: When I don't have money, he still gives me sweets and takes the money later.

I live in Lane Number Six of Shaheen Bagh. The street in front of my house is quite noisy and narrow. The hawkers selling vegetables, fruits and bhujia are the noisiest. The street is quite narrow so their presence creates difficulties. Often, there are accidents on this street. Once there was a Tuesday Bazaar on the street and people were enjoying themselves. A man on a cycle crossed in front of me and then a speeding car came past. I managed to get out of its way but the man on the cycle was not able to save himself and he fell to the ground. His head and arm were quite badly injured. He was lying on the ground, groaning with pain. People moved forward to help him. Just then another car came by and went over his arm. The bone was fractured. People helped him up and took him to the hospital. He returned home after two days and after ten days, he was fine. The car driver also came to see him and apologized.

Mohd Haris

I like seekh kebabs a lot. They have a lot of chilly in them – that's why I like them. Seekh kebabs are roasted on a coal fire and eaten with raw onions and chutney. Once I ate so many seekh kebabs that tears were streaming down my face with all the chilly. Seekh kebabs are sold in my lane in the evening and I eat them at least three times a week. When my friends come to visit, I feed them too. Everyone likes the kebabs in my gali (alley). The shop is called 'Famous Kababwala'. I will eat these kebabs as often as I can till I am in this neighbourhood.

Anam Fatima

Every evening at five o'clock, a golgappa man arrives in front of my house. The golgappas he makes are very tasty. My friends and I gather with our money and wait for him to arrive. He gives six golgappas for ten rupees. We call him 'Chachaji'. The golgappas are made of *sooji* (semolina) and the water for them is tangy and delicious. Sometimes, he gives us some golgappas for free. He brings the golgappas on a little cart. You must think that it's very dirty but it isn't. He keeps the cart very clean. I don't know how the golgappas are made but the one thing I can say is that they are yummy!

Ayesha Khan

Our terrace is very large. We children go up to the terrace just as soon as it's evening. We keep playing and all the mothers and aunts keep drinking tea. But when we go up alone, then it's much more fun because when our mothers are present, they keep telling us – "don't run so fast, you might get hurt." They are always anxious. Sometimes, we also have a party on the terrace. It's a lot of fun when we play together. Sometimes, we have fights but only for a short while. Then we make up and start playing together again.

Abeer

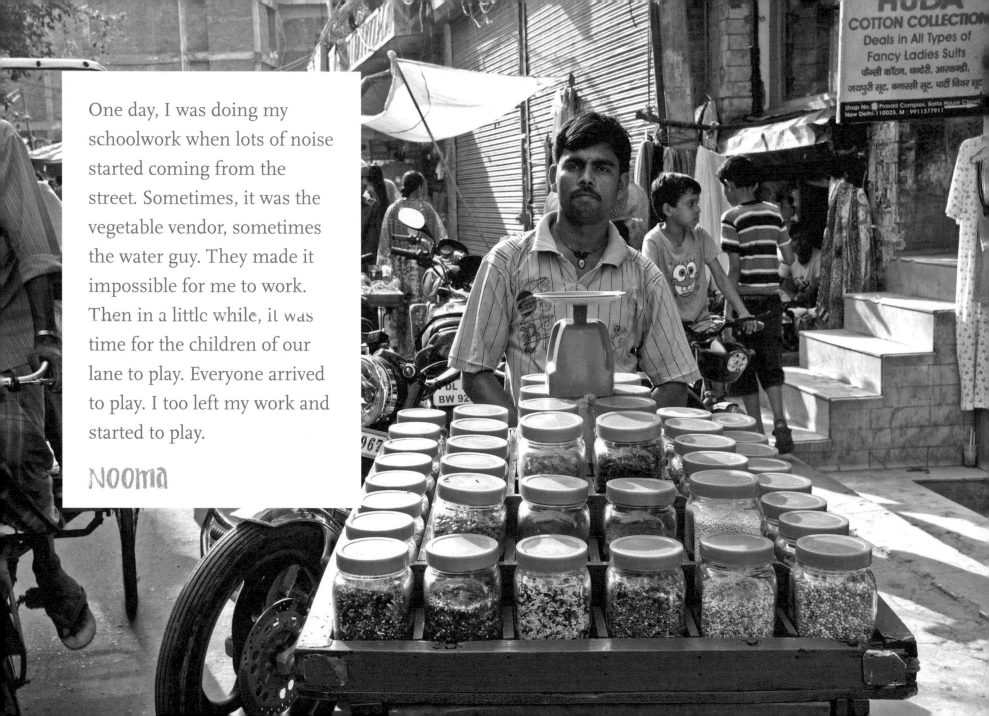

One day, I was doing my schoolwork when lots of noise started coming from the street. Sometimes, it was the vegetable vendor, sometimes the water guy. They made it impossible for me to work. Then in a little while, it was time for the children of our lane to play. Everyone arrived to play. I too left my work and started to play.

Nooma

I like playing on the terrace. One day, when I went up to the terrace, there was a cool breeze blowing. My friends and I played barf-pani (ice-water). I had a lot of fun. I mostly play ice-water on the terrace. In ice-water, one person is chosen as the den and she has to catch us all and turn us to ice. When everyone has been turned to ice, then a new den is selected. I like playing on the terrace because there is a breeze up there. There is another building just next to ours and the terraces of the two buildings are joined together. So, while playing, we can jump onto the other one too. We all really enjoy ourselves.

Yashfeen

One day, when I returned home from school, I heard a sound – "choon, choon…" I asked my mother, "where is this sound coming from?" She laughed and then opened a large box. There were two tiny yellow chickens inside. I loved them. I would give them water and play with them. There was a cat in our house. She was very wicked and would drink up all the milk in the house. So, I would mostly keep the doors shut so she couldn't attack my little chickens. But one day, the door was left open by mistake and the cat came in. She grabbed the chickens in her mouth and took them upstairs to the terrace. By the time my father ran up to the terrace, the cat had eaten both the chickens. I cried a lot that day. It was one of my worst days. I still think of them a lot and cry.

Maria Zahid

My cat was called Daisy. She was a month old when she came to me. I took care of her for six months. Once I had gone to a wedding and returned at about midnight. I called out to Daisy so she could eat her food. But there was no sound from her. I thought perhaps she was asleep, but she wasn't even in her basket. I couldn't find her in the morning either. She never came back. I don't know where she is now or how she would be. Whenever I see a cat, I think of Daisy.

Simeen

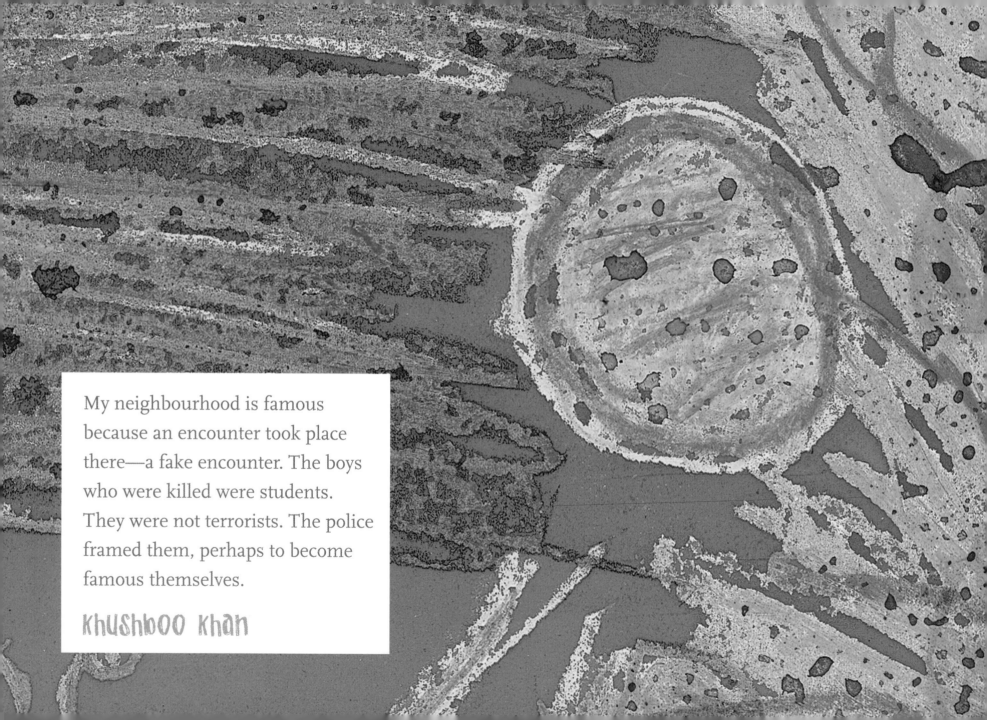

My neighbourhood is famous because an encounter took place there—a fake encounter. The boys who were killed were students. They were not terrorists. The police framed them, perhaps to become famous themselves.

Khushboo Khan

I have lost a lot of things but I've never regretted anything as much as the loss of my neighbourhood's reputation. After the encounter, Batla House has got a bad name. It was on every news channel. I feel bad when I see how my neighbourhood is talked about.

Abeer

I turned right but—it wasn't there! It was supposed to be there; a patch of green—not really a park, with an old pipal tree. I remembered Amma pointing out the tree on countless visits and telling me of how the older children would tell stories of djinns living in the pipal tree. That was about 30 years ago, when Amma had spent a month in Okhla for Badi Ammi's wedding. One of the stories was of a tiny boy suddenly getting stretched all the way to the top of the tree and then retracting back to his normal size. Pretty far-fetched, if you ask me, but Amma says his brother swore it had happened and that after that, the boy had suddenly grown very tall. You'd think they'd have heard about adolescent growth spurt, no! Anyway, djinns or no djinns—the pipal tree was nowhere in sight. Had I turned at the wrong crossroads? I didn't think so.

Badi Ammi is my grandmother's older sister, Amma's Khala (maternal aunt). She's the one who continued to live here, in Okhla. We live in Noida and so do Nana and Nani. I like living in Noida. It's all very organized, not like here. There's a park just in front of our house and you can order in almost anything

on the phone. You can't always do that in this part of Okhla, certainly not pizza! When I was little, I spent a lot of my time here. But now, I'm in senior school and there's homework and extra classes and swimming. I rarely get to visit. It's been months since I was here. But today is a special day and I wouldn't have missed coming here for anything. It's Bade Abbu's birthday and we always have dinner together. So, even though I had to stay back in school for play practice, I convinced Amma that I was grown up enough to catch the school bus to New Friends Colony, cross over to the Zakir Nagar side and then walk the short distance to Badi Ammi's house. "Well, it is only 5 minutes away," she had begun, a bit doubtfully, "You'll manage, won't you, Huma?" I'm 13 now and, of course, I can manage a 5-minute walk through Okhla. At least, that's what I thought. But that silly old pipal tree, that's my landmark for the beginning of the twists and turns to Badi Ammi's house—oh, where had it gone?

Nani keeps telling Badi Ammi to move out of Okhla but she doesn't listen. "Farzana," she sighs, "You may have forgotten what it was like in our childhood

but I haven't. I feel close to Ammi and Abbu here. Anyway, you all keep visiting. So, what's the problem?" Well, here was the problem—me! Not knowing the way anymore, I'd been walking for at least half an hour and somehow I'd landed up near the river. Everything looked so different. Many more buildings, fancier shop windows, more signboards... How do the trucks with the construction material move in these narrow lanes! When Nani and Badi Ammi were growing up here, there were no flats, only one-storey bungalows. In fact, people were only just moving into their part of Okhla - Zakir Nagar. Miyan, their father was in the Jamia University and Nani says that everyone used to know everyone. The children would all walk down to the river every day. People would fish in the Yamuna, even those who didn't live in Okhla. Nani remembers a pair of *shikari*s (hunters) called Wali Mohammed and Titar who knew the river really well. They would organize the bait and take people to those parts of the river where the fish were biting.

I don't think the fish are biting now! The river is filthy, with a capital 'F'. You'd think that would drive people away but actually, it's the opposite that's happening.

More and more people are moving in. Everyone doesn't know everyone anymore. Nani and Badi Ammi feel sad about it but Amma told them they're just fixed in their ways. "What about people like Salman bhai," she pointed out, "who came from Bulandshahar twenty years ago and now has a big export business?" "If he'd stayed on there, he would have just got some ordinary job," she said, "but here he has done well—his kids are now at university and they have their own house. And he helps younger people from Bulandshahar who come to Delhi looking for jobs or college admissions."

As I turned into a quieter lane, with smaller houses, I imagined the lives of the people who lived in them. Where had they come from? Where did they want to be? What were they doing right now? I read the nameplates on the gate as I walked along. Mohd Qasim, Asif Khan, Hashim Ahmed, ST Hasan, A Rahman and then—Begum Noor Hussain. There was a girl about my age on the terrace. In the distance, two kites danced in the gentle breeze. The girl was facing the other way but I could hear her humming. She had a long plait and her arms

were spread wide. I thought of Amma and Baba and the picture I had taken of them when we were in Manali. The sky is pink in that too and Amma's arms are spread out. Amma had posed, like Shahrukh Khan does in all his songs. She and Baba are both laughing in the photograph, happy and free.

They won't be happy now, I thought. It's past *maghreb* and Amma will be losing it! She'll never let me go anywhere alone again. How could I lose my way here! It's like my other home. I've been coming here since I was a baby. Nani had my *bismillah* (religious ceremony marking when a child learns about Islam) here and Badi Ammi let me keep a parrot in her house when I was little. I learnt to play *stapu* (a game that involves jumping with one foot) with Humaira-Sumaira, the two girls who were Badi Ammi's neighbours for a while. And the annual kebab party that Bade Abbu used to organize on Eid was such a treat! So many people would come for Eid – and not just from the neighbourhood. He stopped doing that a couple of years ago. "We've lost that time," I heard Badi Ammi say to Amma last Eid, "Not many remember to even wish for Eid, let alone come

visiting." My cousin Tipu told me that in his school, after a special assembly for Eid, some children were saying—"why do we have to do this, it's not like anyone celebrates Eid in India!" My thoughts were—"what about us! We celebrate it, we're Indians!" When I told Nani about it, she just said sadly, "Think of what they've lost, those children."

Just then, I heard a kitten mewing and looked around. I spied it, partially hidden by a parked scooter. I bent down and stretched my hand out to it. It mewed again and poked its head out. A little girl came out from one of the houses, calling "Daisy, Daisy, Daisy!" When she saw me, she asked, "Is it my Daisy?" I smiled and said, "If she's small and black and white, then, yes, it is your Daisy." "Daisy!" she exclaimed in excitement and rushed out. The kitten bounded out and the girl picked her up and kissed her. "She was lost," she said to me, "But you found her!" I hadn't really found her. She'd been there all along. I just sort of looked in the right direction, no? A bell tinkled and I stepped to one side as a young girl went past on her bicycle. I smiled at Daisy and her reunited owner and said, "Now I have to find my way home." And I headed out of the lane.

I came out onto the main road and smelled the warm delicious smells of kebab and roti. People were eating at the kebab stalls and I thought of dinner waiting at Badi Ammi's. I looked left and right and tried to figure out which way to turn. An empty rickshaw came towards me and I finally decided to take it. "Nafees Road, Gali No. 5," I told him. He sped off and as the rickshaw turned right, I saw the stump of the pipal tree. The tree had obviously been cut down and some construction material lay around, obscuring the stump. But now that I was sitting in the rickshaw, I was at a height and could see it clearly. "So, that's why!" I thought to myself.

"Will the bird go to *jannat* (heaven), Harounbhai," I heard a voice ask. It was the boy and girl I'd seen at the riverside. My rickshaw went past them as he swung his bat and smiled at her, "I don't know, Zainab. Do you think it will find its way?"

I wondered what they were talking about. Don't know about the bird, but I had found my way.

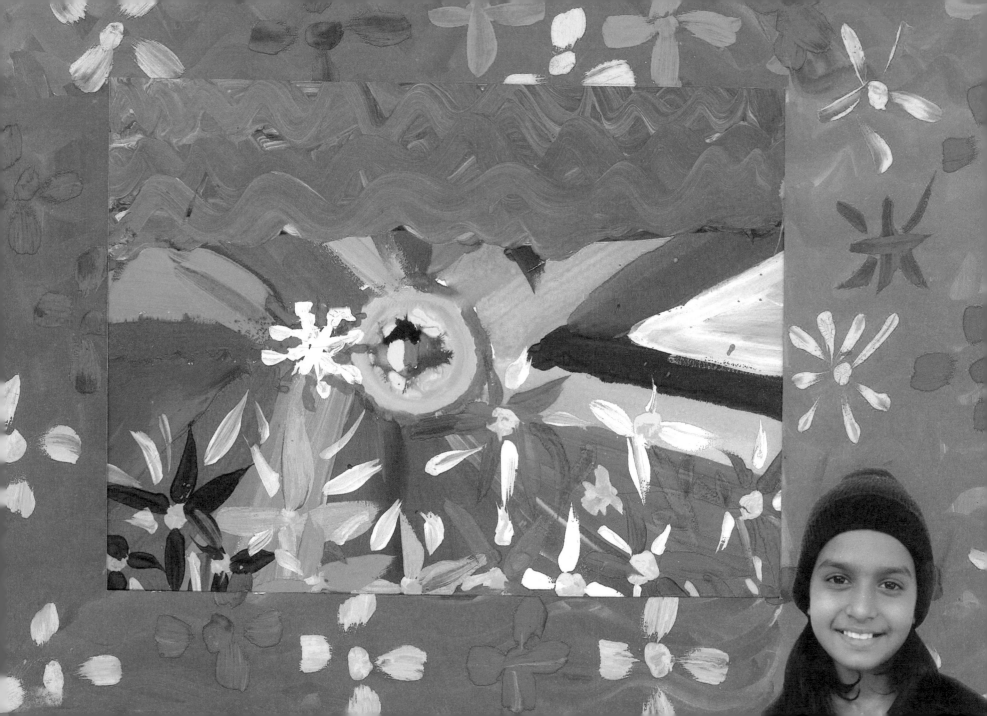

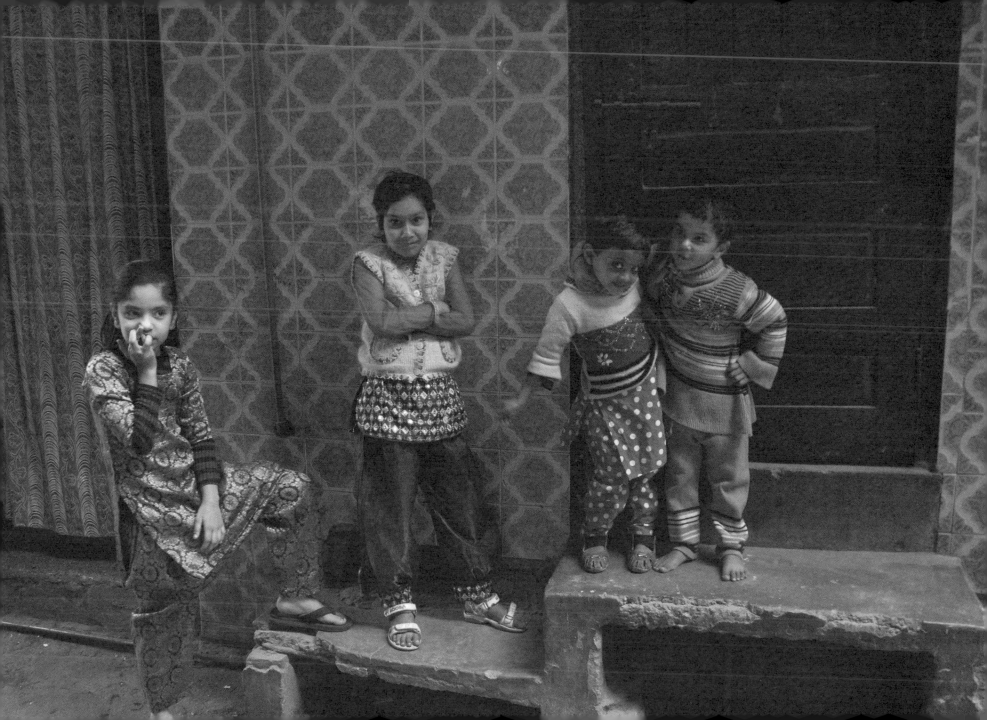

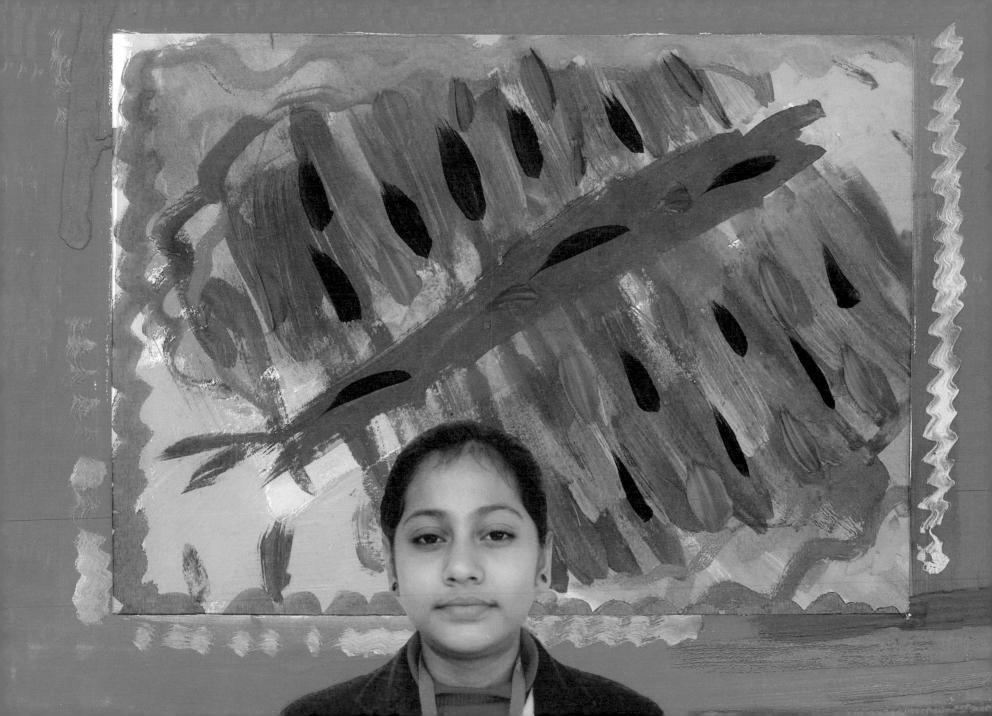

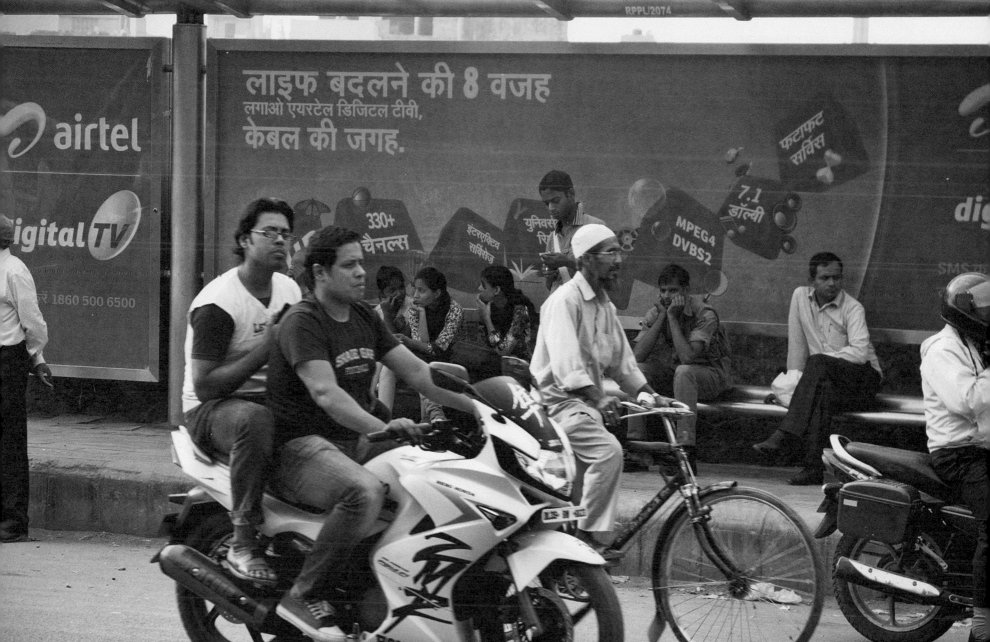

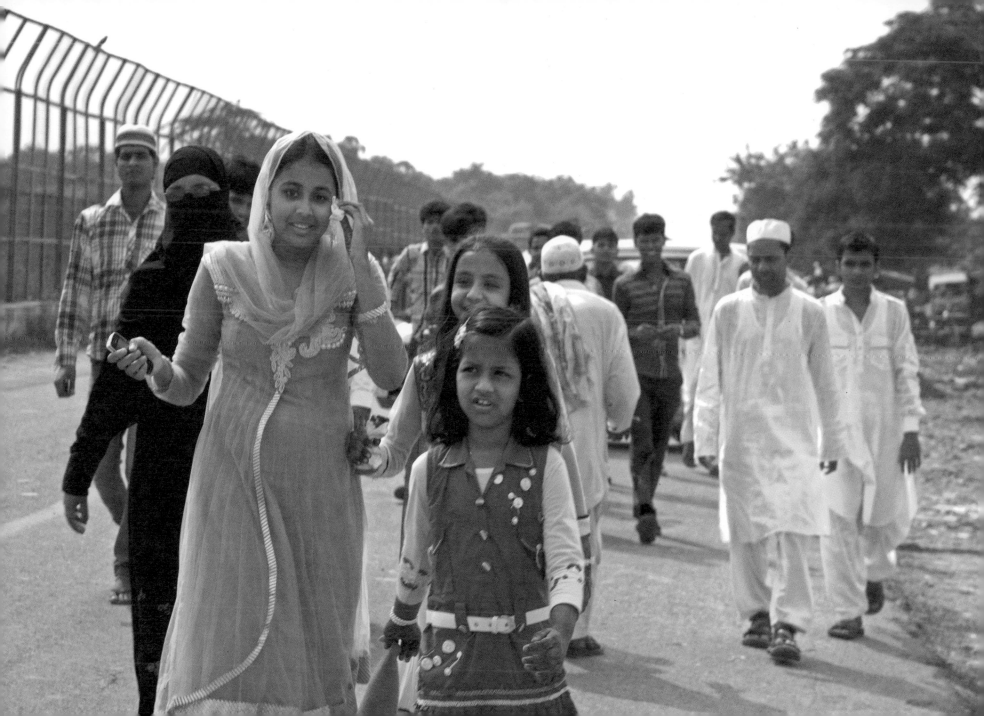

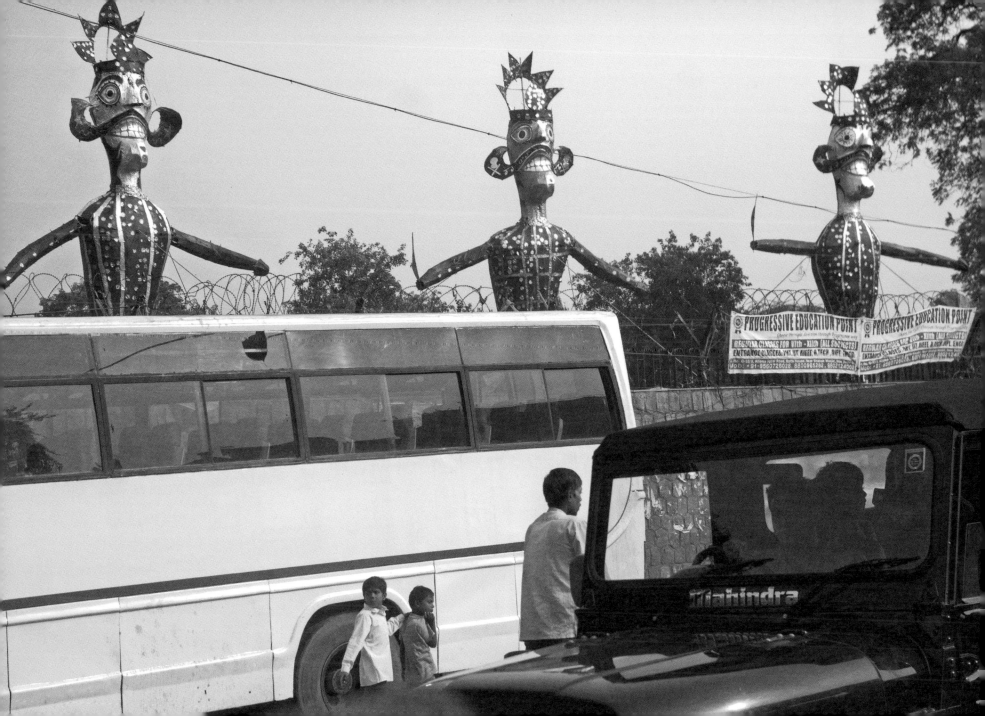

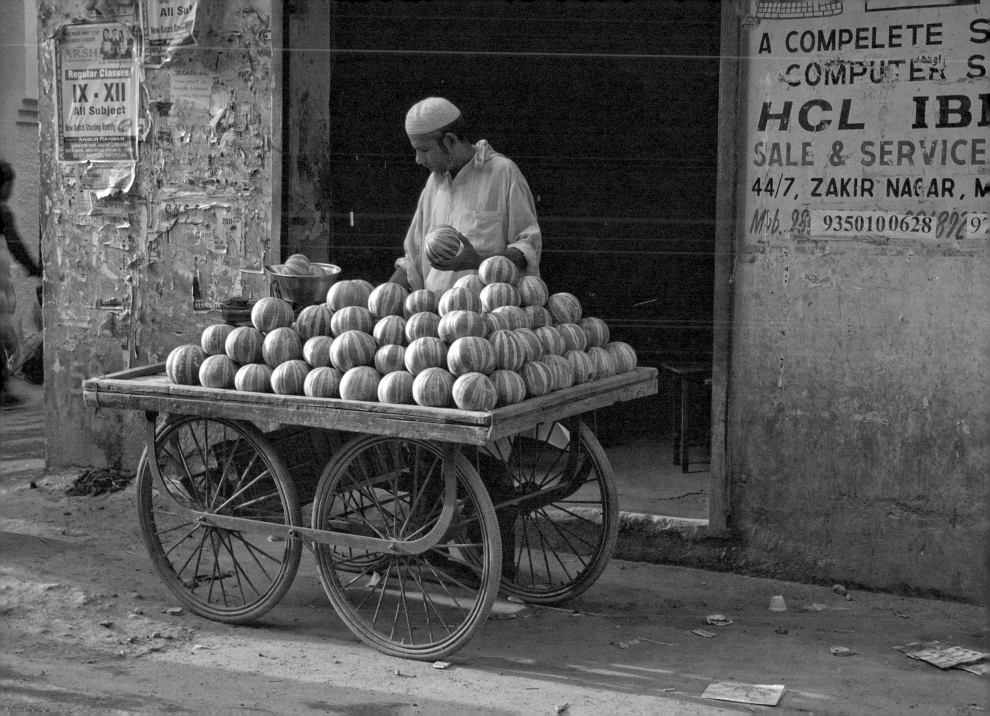

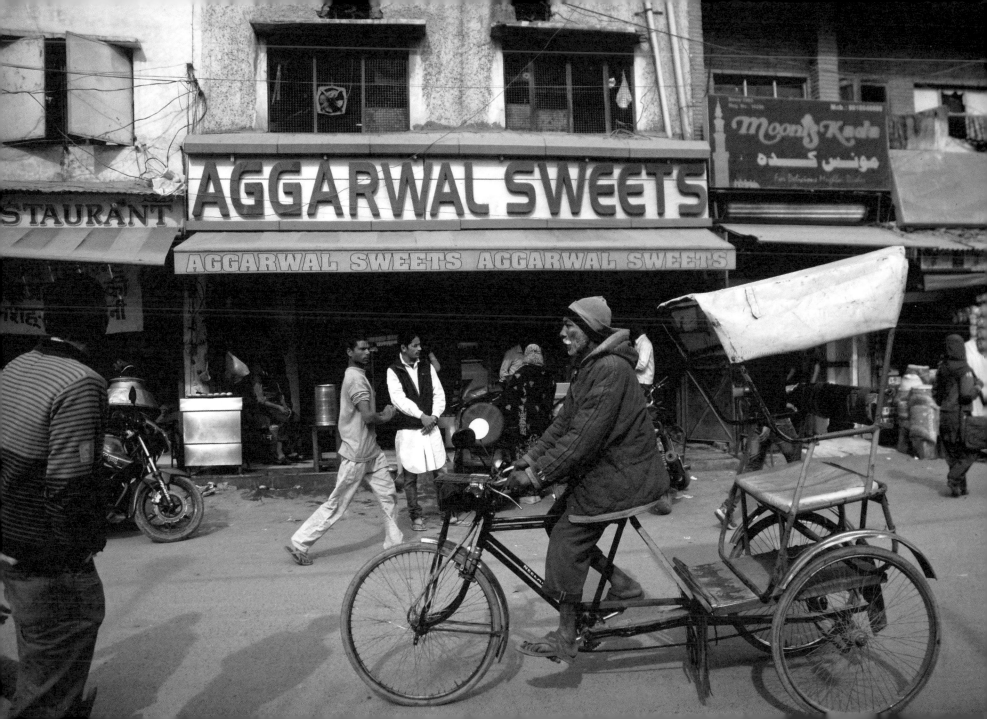

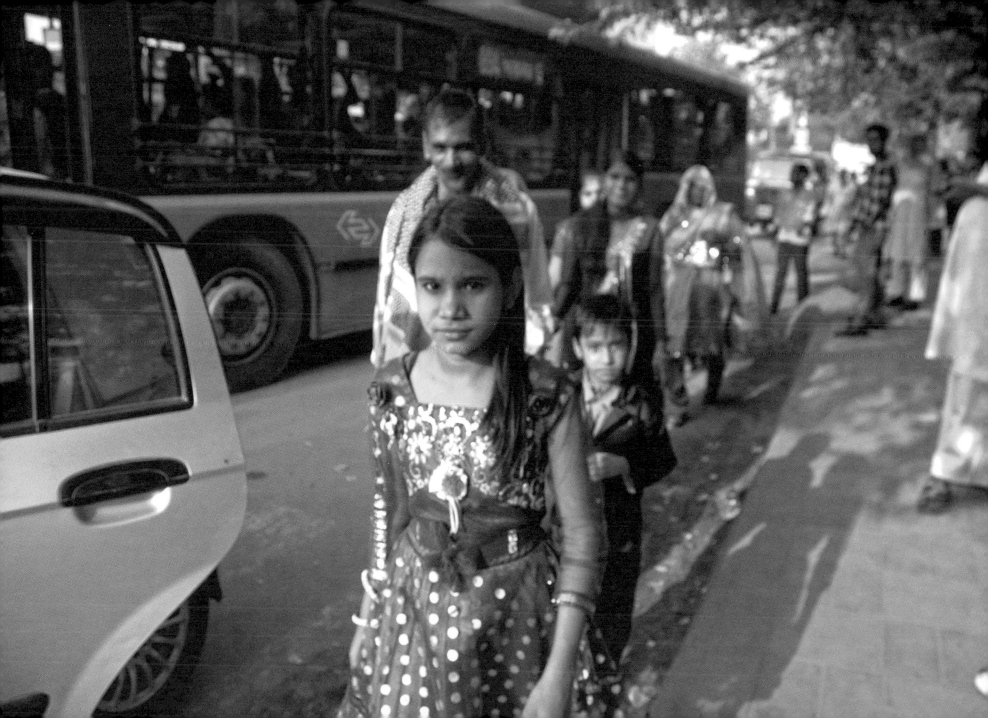

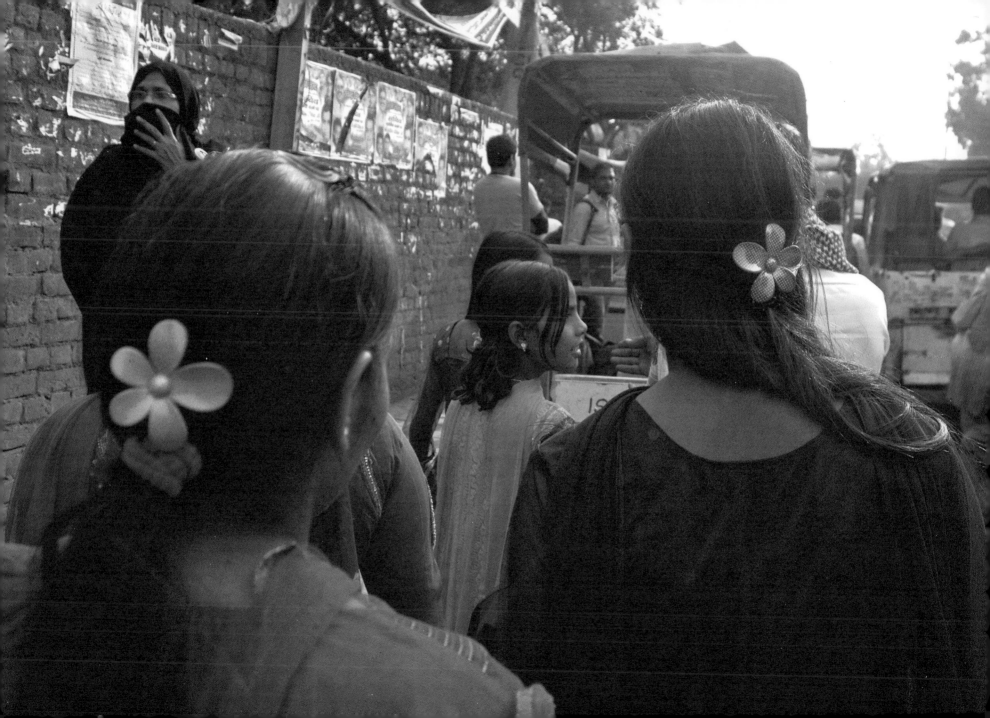

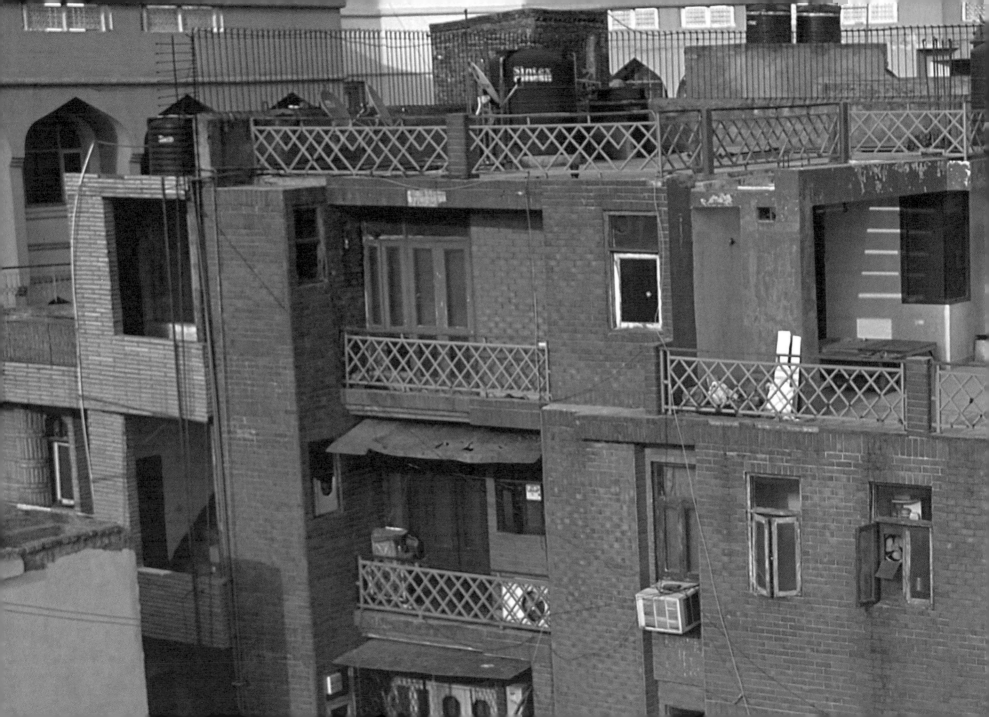

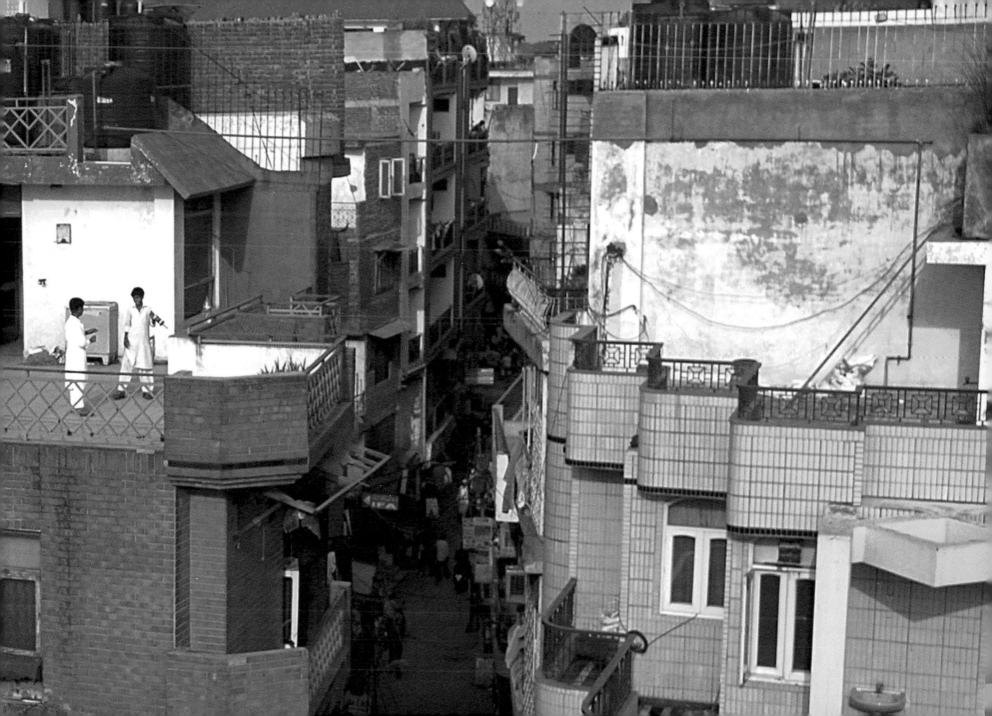

"I wish I were a school topper

a footballer

a dancer"

"I wish I had a lot of birds
I wish I were a bird"

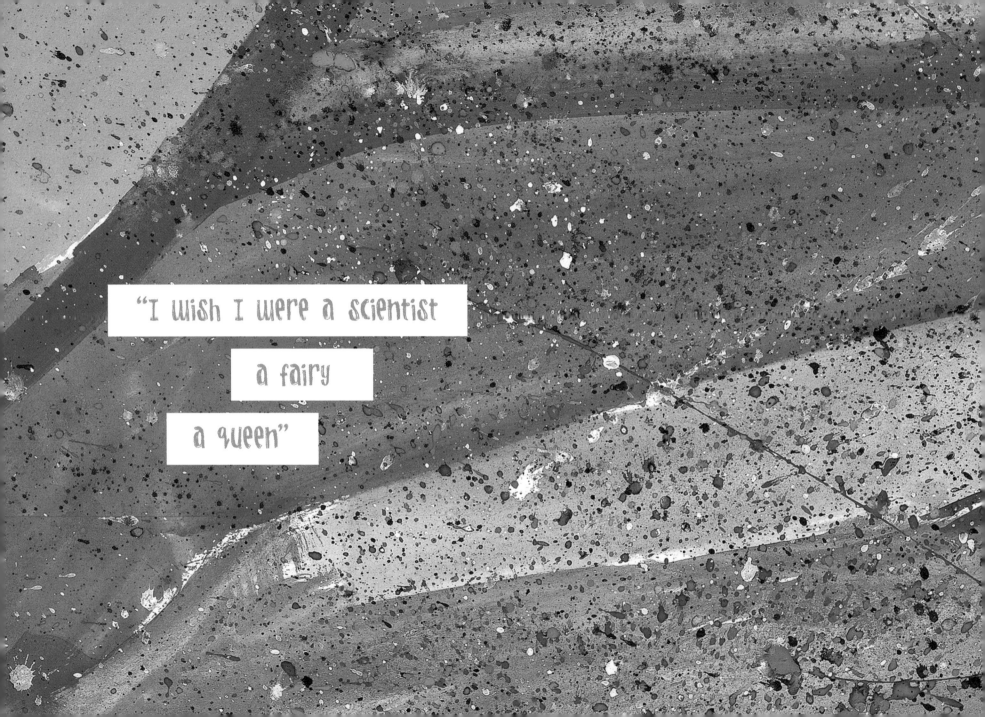

"I wish I were a scientist

a fairy

a queen"

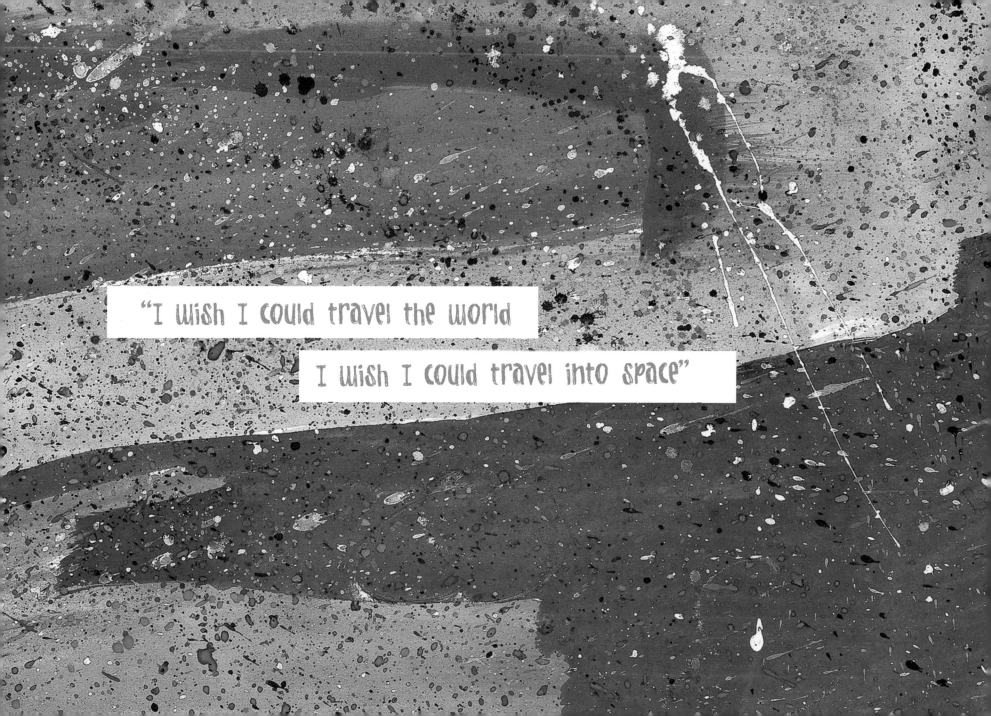

"I wish I could travel the world

I wish I could travel into space"

"I wish my wishes would come true"

Everyone has wishes that they would like to come true. The children in this book and I began our interaction with that – a short sentence beginning with the words "I wish", one from each one of them. And when we put them all together and read them out loud, that list of wishes had a rhythm that made it seem like a poem. Did it seem like that to you? Did it have any of your wishes? Did it make you want to share yours?

This book comes out of a workshop that I and my friend and collaborator, Sherna Dastur, did with 20 children from two schools that are part of Jamia Millia Islamia in February 2010. When the Batla House encounter happened and news vans lined the streets of Okhla, thrusting the camera into the faces and homes of residents, I wondered what it was like for the children. I wondered what they felt about what was going on, as they went in and out of their homes and streets. No one had really bothered to ask them, to talk to them about their lives, not the lives of grown-ups but that of children, in a place that so many labelled negatively—I wanted to. And so, with support from Jamia Millia Islamia, Sherna and I conducted a writing and art workshop that led to this book.

When we met the children on the first day of the workshop, they were friendly but very uncertain about what we would be doing. When we spoke about writing and drawing from their own lives, they were a little bewildered — "why would anyone be interested in that? it's so ordinary," they said. But they humoured us and we began with simple exercises – single-line sentences and colour-play. We spoke of freedom and love and loss. When had they experienced these? What words would they use to describe what they had felt? Did those feelings have a colour or a palate of colours? Did they have a texture? The children began to have fun, they started asking us questions, and they started

showing us glimpses of their lives. They wrote and created art about their homes, terraces, mosques and train tracks that lead to the villages that their families came from. And in those everyday stories, bigger things crept in—the Batla House encounter and growing up as a Muslim in today's world. You will have seen Khushboo's drawing and Maria's writing that refer to it. As Abeer wrote, "I have lost a lot of things but I've never regretted anything as much as the loss of my neighbourhood's reputation."

What do you think when you read and see their stories? They certainly made me think a lot. I saw a detail in one of their drawings and I thought of what must have happened before. I read a piece of their writing and I thought of what could have happened after. I began to write and so, I came up with the stories that you have read in the book. They are my stories but they are also connected to the children's stories.

What Sherna and I did in the workshop prompted what the children wrote and created. And what the children wrote and created prompted my stories. For example, when we asked what is special about your home, each of them looked back at where they live and searched for it. For one it was the the colour of his house, for another, the bustling market. And for yet another, it was the nameplate that unlike the rest of the houses on the street had the mother's name instead of the father's. That started off one of my stories. And so, I think this book is a kind of dialogue.

We hope this dialogue will continue. We hope that others will explore this busy, congested area that is teeming with stories that the newspapers and television channels don't bother with, stories that belong to Haris and Amna, Tabish and Nooma, Simeen and Shahana and Anam, and all their friends. Perhaps, they can also belong to you.

–Samina Mishra

Mehak Aham Haaris Simee Tabish Ayesha Nida

Abu Bakr Maria K Mariya Z Shah e Haider Saba Shahana Amna

khushboo Zia ur Rahman Aliya Yashfeen Abeer Nooma Faizaan

Acknowledgements

This book has had a long journey and has gathered many allies along the way.

It wouldn't have existed had it not been for the support received from, first of all, the children who shared their stories so generously; Jamia Millia Islamia, which offered crucial support both at the beginning and the end; Sherna Dastur, who jumped into what was just a vague idea at the time and brought all her artistry and vision to the project; Kunal Batra, who walked with me, listened and took the pictures the book needed; S. Gautham, who supported and cheered from the sidelines; Sayoni Basu and Anushka Ravishankar, who really started this book off and stood behind it all the way; Tina Narang, who understood that this book needed another kind of birth, and Bipin Shah, who made it possible.

Thanks are due, for financial support towards dissemination and for their belief that this was important, to Salman Khurshid, Harsh Singh Lohit, Aniruddha Sen Gupta, and the generous person at my Chandigarh talk who did not want to be named.

I am grateful to Poonam Batra and the team at RRCEE, and Sujata Noronha and the team at Bookworm for believing that the book should find its way to myriad readers.

Big thanks to Paromita Vohra and Nandini Chandra for their friendship and critique, to Imran Batra for being the first reader of my stories, and to Rehana and Mihir Mishra for everything, always.

Samina Mishra